ISABEL SCHULZ

KURT SCHWITTERS
—
MERZ ART

ISABEL SCHULZ

KURT
SCHWITTERS

MERZ
ART

HIRMER

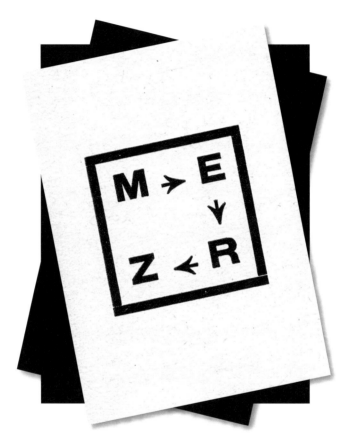

1

MERZ SIGNET

1923

CONTENTS

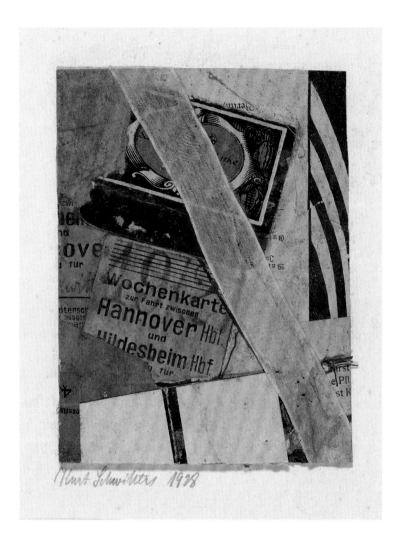

2
UNTITLED (HANNOVER AND HILDESHEIM)
1928, collage

NEW BEGINNING
—

Kurt Schwitters numbers among the artists of the historical avant-gardes in Europe who sought new, contemporary forms of expression in all areas of creativity during the interwar period. He made a special and influential contribution to this search with his "Merzkunst" ["Merz art"]. His works were made out of materials normally alien to art and shocked audiences, for they questioned valid aesthetic categories and conventional perspectives. "Liberation from all chains"[1] and "complete impartiality"[2] were crucial pre-conditions for Schwitters' work in the period of radically new beginnings during the Weimar Republic. Schwitters regarded the values inherited from the previous imperial era that had become obsolete with the same suspicion as all dogmatic programmes and any type of appropriation of art for political purposes. He actively opposed reactionary attitudes such as nationalism and militarism. Schwitters believed in autonomous art, which "was the most useless thing in the world"[3] and "desired to have an impact through nothing other than the fact of its existence".[4] He ascribed a liberating and reconciliatory function to such an art – and not only for his era, which was riven by social unrest and economic problems.[5]

HANNOVER
—

Despite its provinciality, Schwitters rightly described his home town of Hannover in 1929 as "a modern art city",[6] since it provided prominent spaces for contemporary art, thanks to the Kestner-Gesellschaft founded in 1916 and the progressive museum director Alexander Dorner. If Schwitters had not decided to follow his son Ernst into exile in 1937, forced by the defamation and persecution of the Nazis as a "degenerate" artist, then he would surely have remained in Hannover. Although he often travelled to the art centres of Central Europe during the 1920s, none of them attracted him enough to settle there permanently. The idea of a life as a bohemian was alien to him; he seemed outwardly more like an inconspicuous petit bourgeois than an enfant terrible. For the development of his Merz art the confining setting of his home,

3

IN HANS NITZSCHKE'S STUDIO, HANNOVER
ca. 1925 (from Schwitters' photo album)

4

KURT SCHWITTERS IN FRONT OF THE SCULPTURE "DIE HEILIGE BEKÜMMERNIS"
[THE HOLY AFFLICTION], 1920

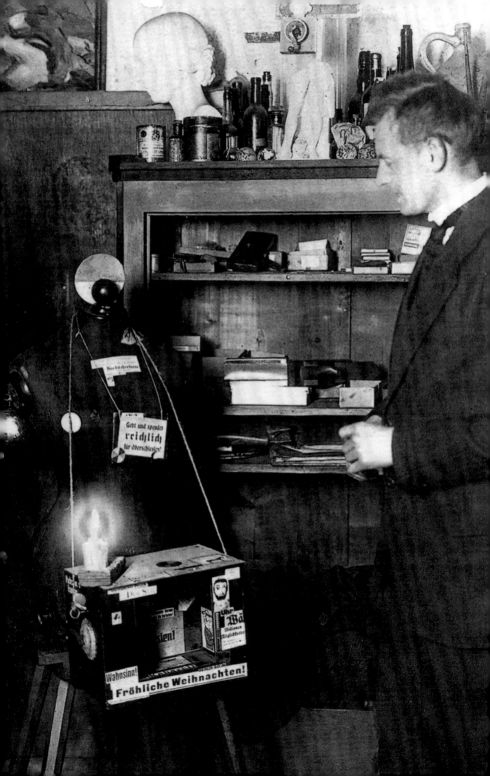

the culturally conservative climate of his home town, together with the spiteful attacks on him in the national press presumably supplied him with the necessary friction, providing him with sufficient themes and impulses for his art.

From his home in Hannover, Schwitters maintained close contact with key representatives of international Modernism. In the 1920s he was active between Paris and Berlin, Amsterdam and Prague as a performer-artist, critic, publisher and typographer. The need for change and to discover an artistic means of expression that corresponded with the contemporary reality of a modern mechanical world, with all its speed and growing consumption, allied him with like-minded colleagues. His friends included Hannah Höch, Raoul Hausmann, Kate Steinitz and Theo and Nelly van Doesburg; joint projects linked him with Hans Arp, El Lissitzky, Walter Gropius and Jan Tschichold. The most important advocates and the propagators of his art were the art dealer and publisher Herwarth Walden from the Der Sturm gallery in Berlin, as well as the publisher Paul Steegemann and the journalist Christof Spengemann in Hannover. In 1919 they helped him to rapid recognition in the art and literature world beyond his immediate region.

COLLAGE
—

Schwitters discovered the technique of collage and montage, that is, the composition of a whole from unconnected fragments, at the end of 1918, after he had finished his studies of painting at the Academy of Art in Dresden and had undergone an artistic development towards abstraction. He adopted this method as the aesthetic principle of his work. This approach remained a constant in his oeuvre independent of all the transformations in the stylistic formal language of his work, which derived from Expressionism, absorbed influences from Cubism and Constructivism, and eventually evolved to a biomorphic abstraction. According to Tristan Tzara, co-founder of the Dada movement in Zurich, collage is the "most revolutionary" visual means of expression; for the American critic Clement Greenberg "it is the most succinct and direct single clue to the aesthetic of genuinely modern art".[7] The collage

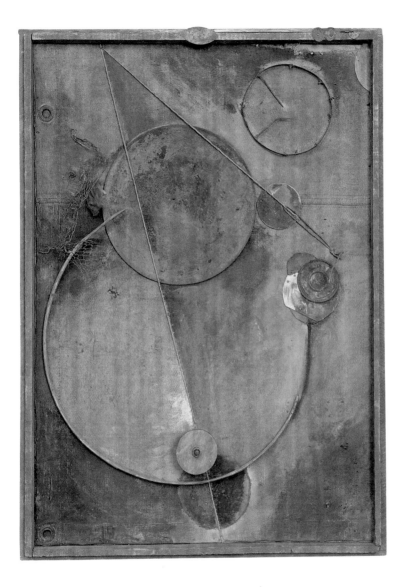

5
REVOLVING [FORMERLY: GLOBAL CIRCLES SPACE.]
1919, Merz picture

6

MERZ PICTURE 29 A. PICTURE WITH TURNING WHEEL

1920 and 1940

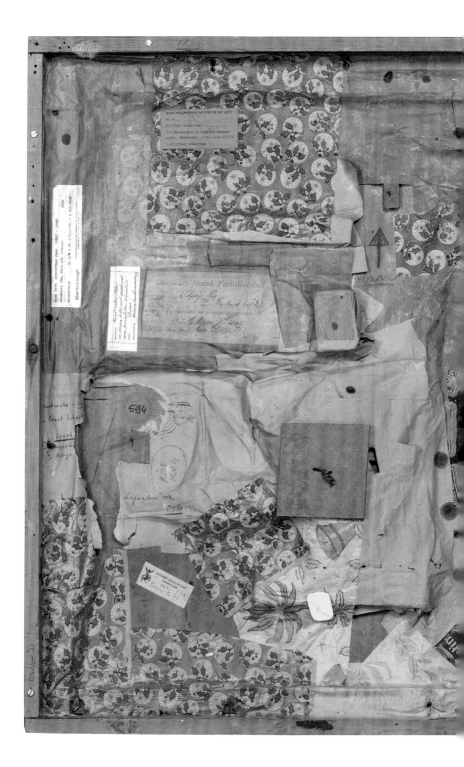

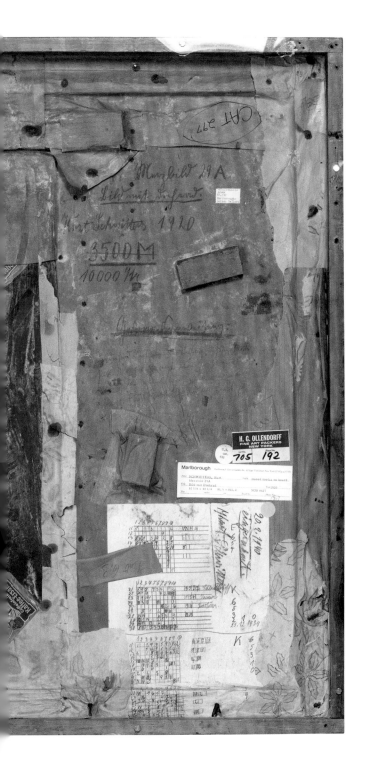

7

REVERSE OF: MERZ PICTURE 29 A. PICTURE WITH TURNING WHEEL

1920 and 1940

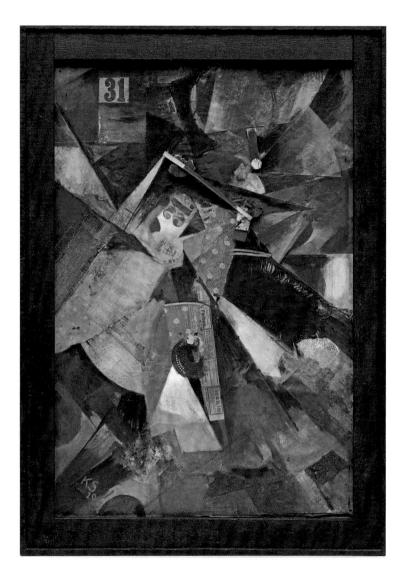

8

MERZ PICTURE THIRTY-ONE

1920

reflects the materiality of its means: it does not produce spatial illusions, but rather makes the two-dimensionality and the physical presence tangible as the actual reality of the picture.

In the following three decades, until his death in 1948, Schwitters made a fundamental contribution with his Merz art to the establishment of the still novel technique as an art form across genres, operating with words, images and space. This took place initially in the face of the staunch resistance of audiences and critics, since he constructed his works primarily out of waste products of everyday use more radically and consistently than almost any other artist. His assemblages framed with simple wooden frames contain objects such as broken wheels of vehicles, stained tarpaulins and rusted tin lids; the text montages incorporate quotations from the everyday world such as official regulations or advertising slogans, whose banality is just as provocative as their purported ugliness.

His friend and fellow artist Hans Arp claimed that Schwitters' collages "have taught us to see life and beauty in the most lowly things".[8] This impression derives from the poetic force of expression of the works, which despite proliferation and cramming, as if a surplus of prinary material were putting pressure on the artist to pack on a maximum of fragments,[9] are carefully composed up to the last detail. The appeal of Schwitters' "aesthetic of the dilapidated, the overlooked",[10] has nevertheless found less broad acceptance among the public to this day than the abstract oil paintings of Modernism.

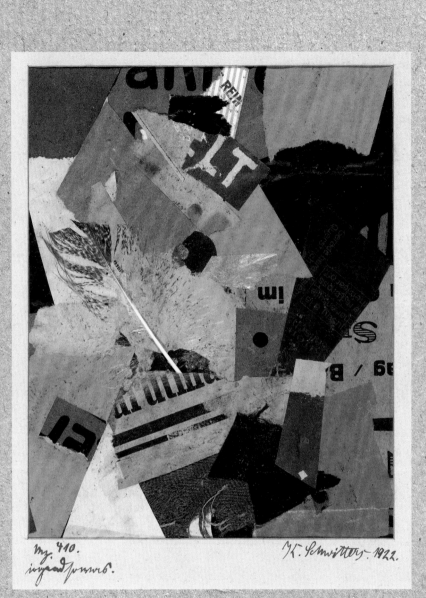

9

MZ. 410. SOMETHING OR OTHER.

1922, collage

COLOUR AND MATERIAL
—

A special quality of Schwitters' visual works is their nuanced colouring. It results from his characteristic procedure of selecting material according to colour and them applying an extra coat of paint He preferred objects that possessed painterly qualities from the outset, including traces of use like dirt, abrasion or creasing, thus exhibiting an uneven, broken surface in terms of colour. The same applies to greatly aged objects, or ones long exposed to the elements, with a large share of grey tones. Schwitters very often utilised transparent gauze, silk or cellophane paper, which appear as glazed coats of colour and furthermore visually fracture the underlying layers of the picture. The roughness of certain materials such as sackcloth, wool or torn paper lends the normally smooth surfaces of the works on paper a relief-like quality.

Although the procedures of collage and montage in general question the pre-eminence of painting, for Schwitters the latter remained of key significance. For him the two forms of expression did not exclude one another, but rather formed a unity. Indicative of his understanding of himself as a modern artist is the reported anecdote of the way he introduced himself with the sentence "I am a painter, I nail my pictures".[11] His assemblages were hammered together, and just like the old, coarse materials he preferred, they display signs of the handwork employed in their creation. Their raw physicality corresponds in no way with our conceptions of an industrial modernity of shiny steel products such as those made at the Bauhaus. Instead, Schwitters practised an archaeology of Modernism.

His colour schemes evolved during the various stylistic phases present in his oeuvre: dark and broken, often gloomy colours dominate in the 1910s. Aside from the natural brown of wooden objects or the ochre of yellowed newspaper, the combinations of yellow and violet or blue and green predominate. In the 1920s we find a broad range of bright and often strongly contrasting, flamboyant colours. Some collages recall the gaze through a kaleidoscope in their swirl of colours, while others present a subtly exploited tone-in-tone scale.

In the mid-1920s Schwitters' involvement with the objectives of the Dutch De Stijl group around Piet Mondrian, whose paintings are reduced to the primary colours, resulted in works with relatively large and clearly delineated blocks of colour. In the 1930s he chose hues with more grey tones, influenced by the impressions of light experienced in Norway. The later assemblages are more

predominantly painterly. The objects in them are covered with a quasi-impressionistic, airy coat of colour. In addition to these, he continued to make brightly colourful works in which bright red accents repeatedly stand out, almost like a personal trademark.

Schwitters usually created the collages in one working step, covering the entire surface with flour paste and moving the papers back and forth in the wet coating until they were worked into the composition as reliefs. He often cut the edges of the thickened paper in order to create a more balanced composition, or he mounted the picture in a passe-partout with a window that presented the desired detail of the image. Instead of the usual support made of one piece, Schwitters' pictures often have rear sides that are similarly composed of various overlapping layers (fig. 7). We can frequently see that assemblages and collages are finally (and not seldom almost unnoticeably) worked over with brush and paint. This can often only be detected in that painted lines or applied spots of paint extend over the glued edges. The collage artist employed painterly means in order to add contrast and tension to the compositions of found objects or to reduce stark ruptures in the surface.

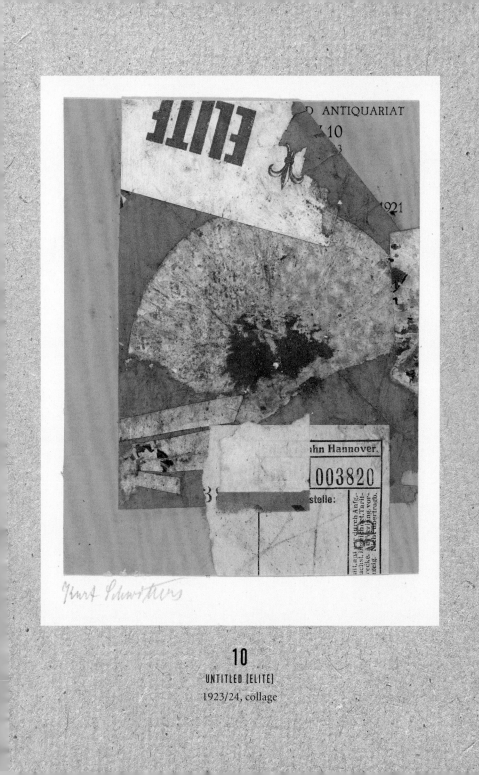

10

UNTITLED [ELITE]

1923/24, collage

K. Schwitters 1920

Merzzeichnung 141 Lenzgericht

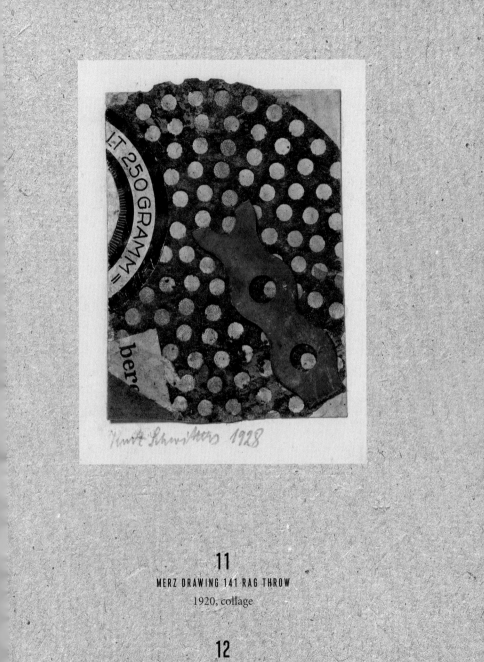

11

MERZ DRAWING 141 RAG THROW

1920, collage

12

UNTITLED (250 GRAMMES)

1928, collage

13

MZ 1600 ROTTERDAM

1923, collage

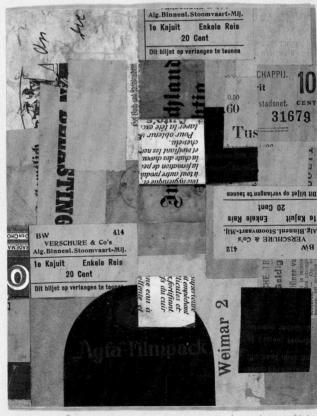

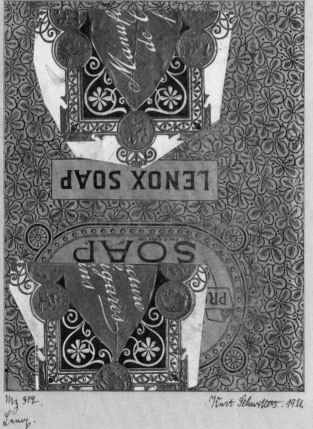

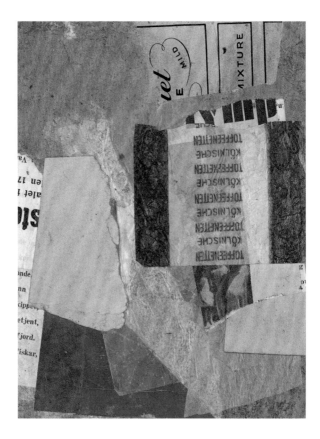

15
UNTITLED (COLOGNE TOFFEES)
1937/38, collage

16
MZ 308 GREY.
1921, collage

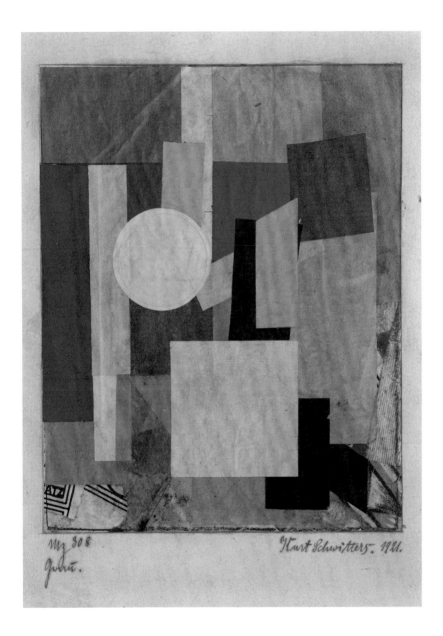

Mz 308
grün.

Kurt Schwitters. 1921.

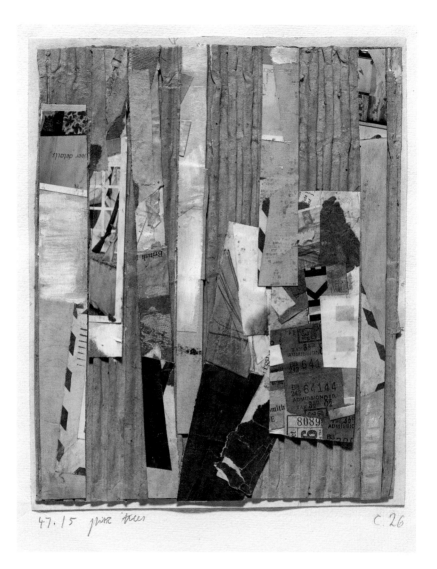

47.15 pine trees C. 26

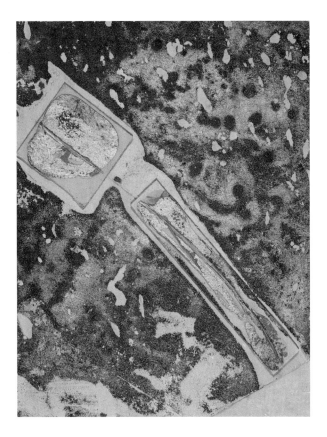

17
47.15 PINE TREES C 26
1946 and 1947, collage

18
UNTITLED (SILVERY)
1939, collage

19
MERZ 1003. PEACOCK'S TAIL
1924, Merz picture

20

MOTIF: DISPLACEMENTS

1930, oil painting

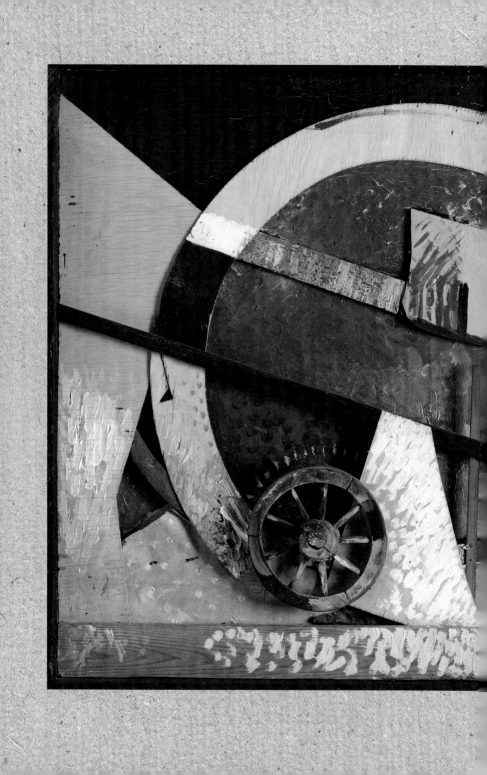

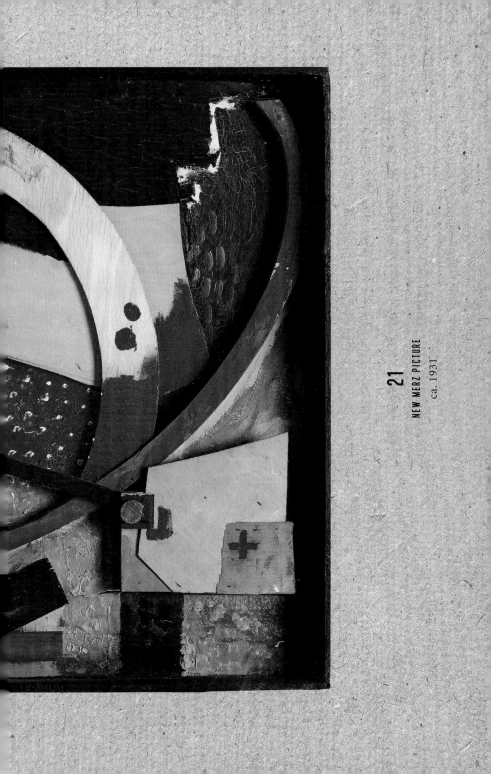

21
NEW MERZ PICTURE
ca. 1931

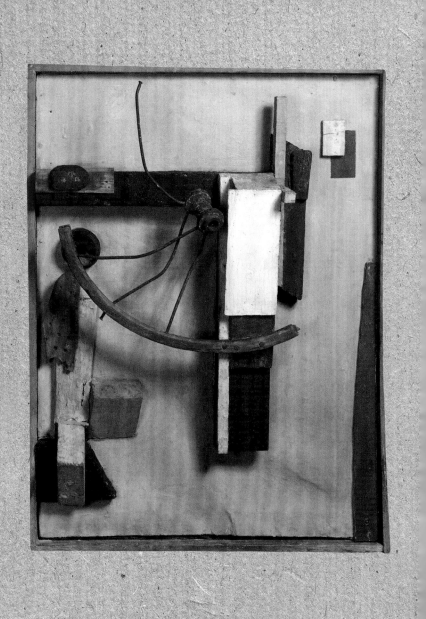

22
MERZ 1926,12. "LITTLE SEAMEN'S HOME."
1926, relief

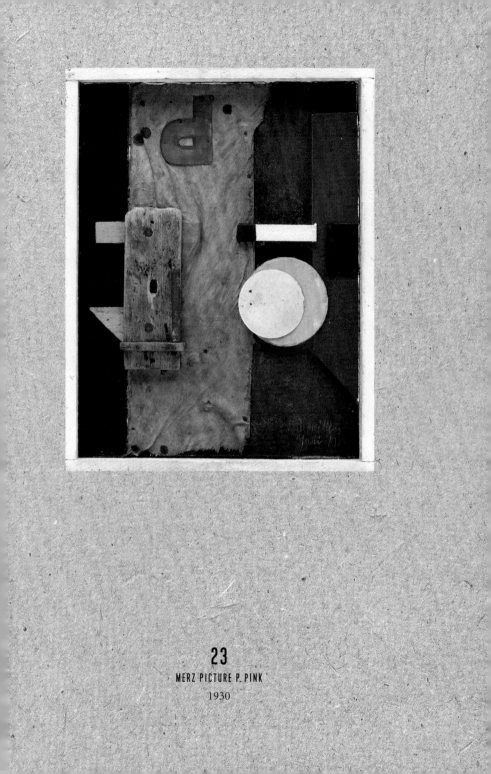

23

MERZ PICTURE P. PINK

1930

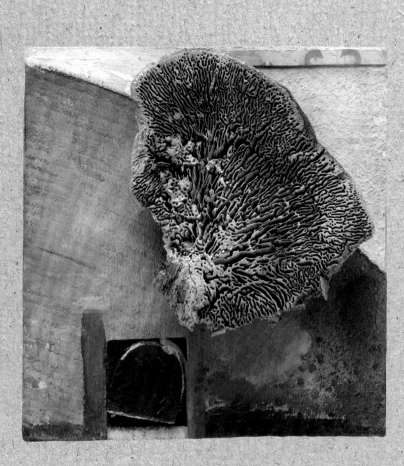

24

FOSSIL

1944/1946, Merz picture

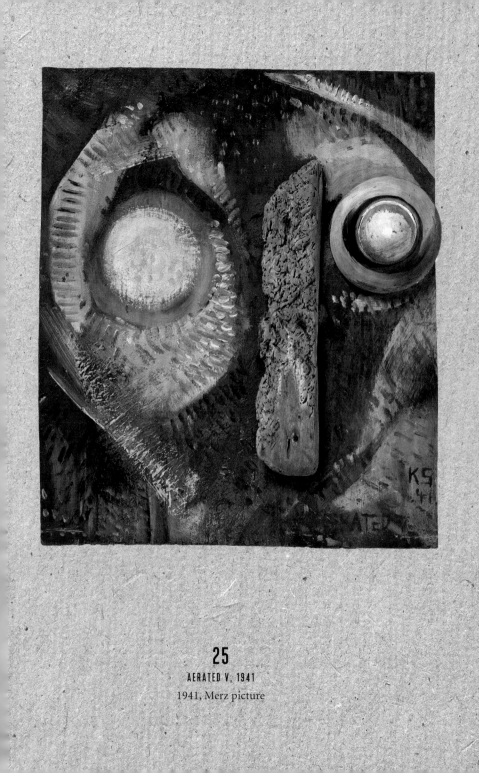

25
AERATED V, 1941
1941, Merz picture

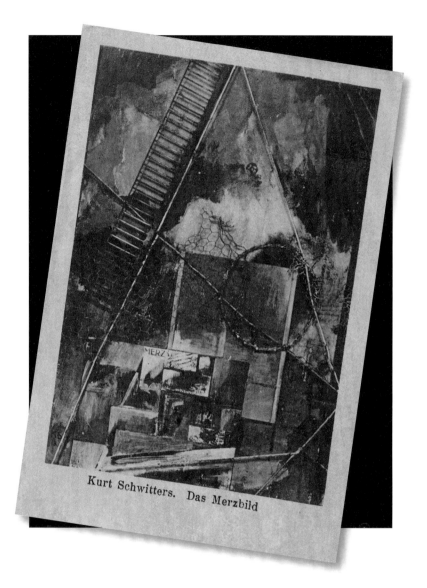

Kurt Schwitters. Das Merzbild

26

THE MERZPICTURE

1919 (lost), picture postcard, Paul Steegemann Verlag, Hannover

MERZ

–

Schwitters was not only an inventive and adventurous artist, author and typographer, but also a skilled networker and self-promoter. In the shifting interface between the art movements of Dada and Constructivism he embodied the one-man movement of "Merz". In 1919 he cut the word out from an advertisement for the *Kommerzbank* and glued it onto one of his innovative assemblages (fig. 26). Within a few years he was able to establish this syllable as a brand and programme for his own unique position. As early as 1922 he claimed that "Every child knows what Merz is."[12] A year later he published the eponymous journal series ("the official organ of the movement"[13]), which exclusively propagated "the Merz idea".[14] By means of insistent proclamations the term Merz finally became a synonym for Schwitters – for his boundary-crossing art programme as well as for his person.

Gathered under this overarching term, his heterogeneous work appears unified. "Merz production may be envisaged as a serial generation of linked expressions."[15] Merz art itself comprises patterns of classification created by Schwitters himself.[16] They arise when "Merz" is prefixed as part of the name of diverse series or groups of works: thus there are Merz drawings (collages), Merz poems, Merz pictures and Merz recital evenings. He titled his address books, listed not in the customary alphabetical order, but by place, as "Merz areas".[17] They define the artist's various spheres of activity, with the starting point of his movements being the so-called *Merz area 0 Revon-Hamburg-Lübeck* with the centre Hannover or "Revon". This is how he had referred to the city since 1920, subjecting its name to the frequently applied principle of inversion as well as abbreviation. The verbal artist, moreover, played with the term Merz in very different, often humorous ways. He remarked "The Merz the better!", sent "Merz-ful birthday greetings",[18] signed holiday postcards as "bathing Merz on Rügen",[19] or referred to a suffering female figure as "Merz-tyr" (a play on the word "martyr").[20] His entire thinking, activity and influence were permeated by this term and the ideas it represented for him.

But what does Merz actually mean? At first only a word fragment and visual element, it soon served as the "name of a genre"[21], denoting Schwitters' artistic procedure and finally representing a "standpoint", even a "world view",[22] which he adhered to up to the end of his life. Merz is a question of perception, of aesthetic experience, which arises from "a transformation in seeing".[23]

Höch

ME

da
da **X** da
da

MERZ

VON **KURT S**

ANNA BLUME

O du, Geliebte meiner siebenundzwanzig Sinne, ich
liebe dir! — Du deiner dich dir, ich dir, du mir.
— Wir?
Das gehört (beiläufig) nicht hierher.
Wer bist du, ungezähltes Frauenzimmer? Du bist
— — bist du? — Die Leute sagen, du wärest, — laß
sie sagen, sie wissen nicht, wie der Kirchturm steht.
Du trägst den Hut auf deinen Füßen und wanderst
auf die Hände, auf den Händen wanderst du.
Hallo, deine roten Kleider, in weiße Falten zersägt.
Rot liebe ich Anna Blume, rot liebe ich dir! — Du
deiner dich dir, ich dir, du mir. — Wir?
Das gehört (beiläufig) in die kalte Glut.
Rote Blume, rote Anna Blume, wie sagen die Leute?
Preisfrage: 1.) Anna Blume hat ein Vogel.
2.) Anna Blume ist rot.
3.) Welche Farbe hat der Vogel?
Blau ist die Farbe deines gelben Haares.
Rot ist das Girren deines grünen Vogels.
Du schlichtes Mädchen im Alltagskleid, du liebes
grünes Tier, ich liebe dir! — Du deiner dich dir, ich
dir, du mir, — Wir?
Das gehört (beiläufig) in die Glutenkiste.
Anna Blume! Anna, a-n-n-a, ich träufle deinen
Namen. Dein Name tropft wie weiches Rindertalg
Weißt du es, Anna, weißt du es schon?
Man kann dich auch von hinten lesen, und du
Herrlichste von allen, du bist von hinten w
vorne: „a-n-n-a".
Rindertalg träufelt streicheln über meine
Anna Blume, du tropfes Tier, ich liebe
KURT S

RZ=

HWITTERS

DAS WEIB ENTZÜCKT DURCH SEINE BEINE
ICH BIN EIN MANN, ICH HABE KEINE.

KURT SCHWITTERS

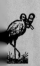

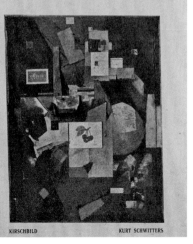

KIRSCHBILD KURT SCHWITTERS

Schwitters "chose an extract [from the word "Kommerz"] in order to assign it a new totality. The concept "Merz" is therefore linked with the production of connections that are evident to the artist's gaze, but also with the arrangement of elements in constantly changing spaces".[24] Merz is a form of the individual appropriation of what already exists and stands for the possibility of situating this in other contexts and combining it anew. When we look at Merz artworks, we experience the individual perspective of the artist. Building on this, in principle the opportunity of a change in perspective arises for us as well, since, as Schwitters believes: "Merz is a standpoint that anyone can use. From this standpoint one cannot only observe art, but all things – in a word, the world."[25] If we follow the Merz aesthetic, art and life ultimately become an inseparable unity. Schwitters too becomes "an aesthetic figure as a component of the Merz world".[26] Life itself becomes an art product, or as Schwitters himself formulated it, "Everything that an artist spits is art".[27]

In German, the syllable "Merz" rhymes with "Herz" (heart) and "Schmerz" (pain) and is almost homophonous with the word for the month of March ("März"), thereby alluding to the idea of a spring-like new beginning. It was presumably selected by Schwitters – certainly not by chance – to designate and position his art in the context of other artist groups with names such as Dada, De Stijl and Der Sturm. In its connection with the German word "Kommerz" [commerce] it expresses profit-making business activity, yet at the same time it encompasses the archaic German verb "merzen" ["to eliminate" or "to segregate"]. Merz art does precisely that: it constructs something new from what is supposedly worthless and has been thrown away; it elevates it to a new level as artistic material, and transports it back into the world of exchange – a promisingly constructive concept seen against the background of current debates on recycling and sustainability.

In 1909 the German word "Commercium" still generally meant "a fusion of two autonomous entities resting on reciprocity […] into a composed whole".[28] In regard to Schwitters' Merz art this definition points to a further aspect aside from the proximity to the principle of montage, namely the confrontation and interchange of the artist with critics and audiences, who played a significant role for him as suppliers of material. This is testified to by the reactions evaluated by Schwitters in his notebooks full of newspaper clippings of reviews and letters from readers. Sentences or formulations underlined there are re-used

in his own text montages. This artistic strategy of productive reception is a fundamental characteristic of Merz art. It belongs on the one hand to the tradition of "critic bashing" as practised in the journal *Der Sturm*, and on the other hand follows practices of the Dada artists, who believed that success first arose in the combination of provocation and reaction, measuring this in the effect on the audience and in the media.

MERZGESAMTKUNSTWERK
—

"Everything was ruined anyway; it was necessary to build something new from the broken shards. But this is Merz."[29] Schwitters' explanation situates the genesis of his collage art in the context of the historical situation after the First World War, while at the same time emphasising the constructive, affirmative approach of the Merz idea, which the artist proclaimed not least to disassociate himself from the demands of politically radical Berlin Dada artists such as Richard Huelsenbeck and George Grosz: "If Dada wants to create the basis for a new world by cleaning up the old one, Merz wants to build up art with the ruins of the old world."[30] The artistic and literary Dada movement, which – in brief – questioned all conventional art and all bourgeois ideals, was ironically described by Schwitters as "the moral seriousness of our times".[31] For him, Dada was only a kind of purifying transitional stage, a period which lacked style as a prerequisite for the necessary renewal. Merz, on the other hand, represented a new beginning and a lasting turnaround and was an expression of the positive, visionary attitude of the artist, who believed in creative freedom and in the transformative power of abstract art. By removing the boundary between art and everyday objects, he aimed at a fundamental change and expansion of art. Ultimately, he strove for a "unification of art and non-art"[32] and conceived the utopia of a "Merzgesamtkunstwerk" ["Merz total work of art"][33] that would combine all types of art and aim to transform life through art. In 1923, he proclaimed in the manner of a manifesto that Merz was "capable of transforming the whole world into a mighty work of art in an unforeseeable future."[34] Since the call for totality here is directed solely at art, Merz remains

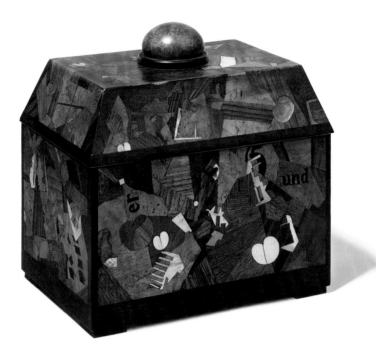

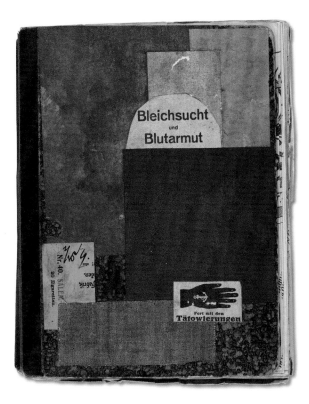

CHLOROSIS AND ANAEMIA – INTERESTING LETTERS

1920, material notebook

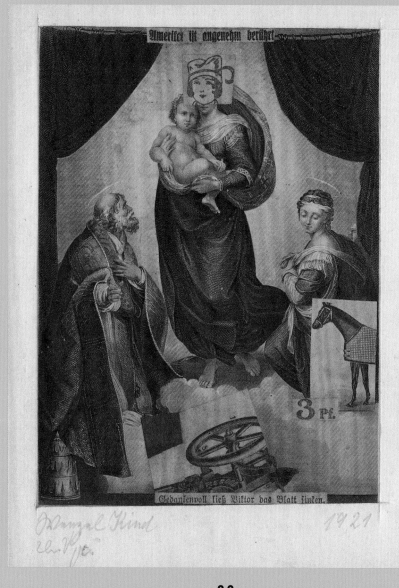

30

MZ. 151 WENZEL CHILD MADONNA WITH HORSE

1921, collage

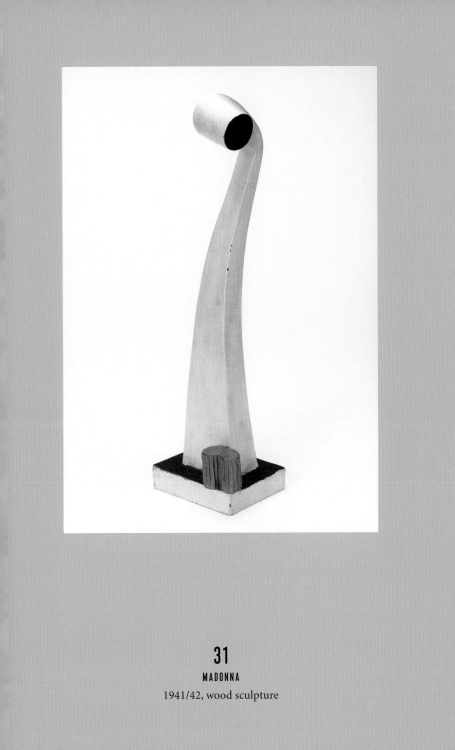

31

MADONNA

1941/42, wood sculpture

MERZ 20
KURT SCHWITTERS

KURT SCHWITTERS (Foto Genja Jonas, Dresden)

ergebenst überreicht von
Kurt Schwitters, Hannover, Waldhausenstraße 5

KATALOG

PREIS 1,20 ℳ

32

MERZ 20 KURT SCHWITTERS CATALOGUE

1927

free of reactionary or other totalitarian ideological tendencies, in contrast to Modernism's other conceptions of the Gesamtkunstwerk. Schwitters' pictures and texts are not explicit calls for the transformation of social conditions, although the Merz works, assembled from rubbish or textual quotations, certainly incorporate a critique of civilisation. In his work a fusion of the realms of art and non-art is carried out proceeding from the medium of art and within art itself, "in that all objects are structured according to the same artistic principles".[35]

Since the principle of collage, the "Vermerzen" [the "Merz transformation"], is applicable to almost anything, Merz works correspondingly exist in the field of the so-called applied arts, that is, arts and crafts, in the form of cushion covers, book covers and marquetry boxes. The elaborate inlaid wood work was carried out by the marquetry master Albert Schulze in Hannover, following designs by Schwitters. In 1922 the Galerie von Garvens, likewise located there, offered cushions by Schwitters, possibly sewn as patchwork following the example of his collages. They have not been preserved, nor is anything more known about them. There are, however, numerous collaged paper book jackets of Anna Blume publications, which Schwitters gave as personal gifts in the 1920s, for example to his fellow artists László Moholy-Nagy and Piet Elling.[36]

Even the treatment of quite traditional pictorial themes such as the motif of the Madonna is not taboo in Merz art (fig. 30, 31). Unlike other avant-garde artists, Schwitters did not completely reject the traditional, but used it to create something new as part of the overall Merzgesamtkunstwerk. In his oeuvre there are numerous collages containing reproductions of depictions of the Virgin Mary. These include Raphael's *Sistine Madonna* from the sixteenth century, one of the most popular devotional pictures and regarded as the embodiment of an idealised conception of art and beauty. In the Merz drawing *Mz. 151 Wenzel Child Madonna with Horse*, the picture is ironically profaned by a few, skilfully placed pastings (fig. 30). Schwitters irreverently transforms the Virgin's face into the face of a "new woman" with bobbed hair. Insignia of the secular values of the modern world from the fields of technology, fashion and sport replace the angels and figures of saints. Snippets from newspapers and advertising catalogues are programmatically allotted the same value – in terms of visual material – as the reproduced icons of European high culture.

While here the humorous and provocative transformations of tradition occupy the foreground, on several occasions during the 1930s and 1940s Schwitters created a sculpture named *Madonna* that represents an "abstract form"[37] reduced to the elementary (fig. 31). He must have held it in high esteem, for it was both free-standing in his apartment in Hannover and firmly integrated into his first two Merz constructions; wherever he stayed for long periods, the figure was present like a protective "house Madonna". Only the last sculpture from 1941/42 has survived, a gently curved stele made of a tapering rectangular-shaped piece of wood. Its main feature is the narrow edge with an oval shape at the top, so that the profile inevitably gives the impression of an elegant neck line and tilted head, characteristic of depictions of the Virgin. This posture makes the slender figure appear as graceful as some of its predecessors from the Renaissance. It is accentuated by three spots of colour: the red circle at the end of the cylindrical head shape acts as a signal and directs the eye to the flesh-coloured "bundle" placed below, formed from a piece of rolled corrugated cardboard filled with plaster. The dark blue surface of the base refers to the familiar colour of the Queen of Heaven's mantle. Schwitters transfers essential features of traditional portraits of the Madonna into the abstraction to such a degree that they would hardly be identifiable as such if the title of the work were not known.

There is a further aspect of Schwitters' oeuvre that is equally unusual: even after he had found his way to abstraction and collage, at the same time he continued to paint naturalistic landscapes and portraits, especially in periods when he had to live increasingly from commissioned art. As a rule, these figurative, conventionally painted works are not counted among his Merz art in the strict sense of the term, but as part of his oeuvre they also belong to the Merzgesamtkunstwerk. The study of nature that did not exhaust itself in pure imitation or in the painting of details remained important to Schwitters throughout his life, alongside abstract work.[38] In the catalogue to the "Great Merz Exhibition", held in 1927 at the height of his career and in which he also showed recent landscape paintings created in northern Germany, he describes self-critically the desire for an "imitation of nature" and the wish not to lose touch with his "earlier stages of development" as "sentimentality".[39] Yet this desire was not a contradiction to the Merz approach, but was a prerequisite for it. The unifying element in both the abstract and representational works lies in the artist's intention to explore both the laws of form in nature

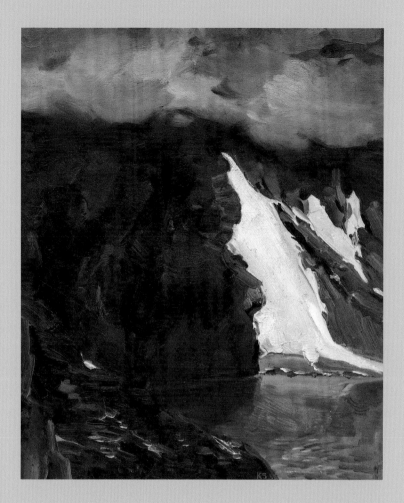

33
UNTITLED (LANDSCAPE WITH SNOWFIELD: OPPLUSEGGA)
1936, oil painting

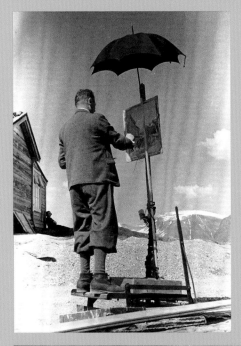

34
KURT SCHWITTERS
AT THE EASEL IN NORWAY
1935 (Photo: Ernst Schwitters)

35
OLDENFOSS
1931, oil painting

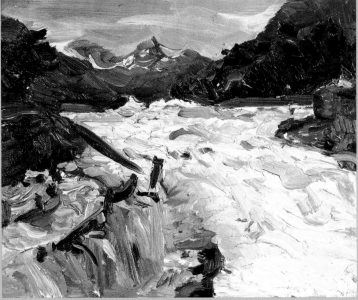

36
UNTITLED (ISFJORD NEAR ÅNDALSNES)
ca. 1938, coloured crayon drawing

37
KIRKSTON PASS
1948, pencil drawing

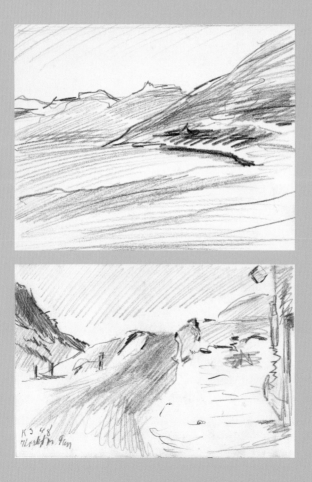

and the intrinsically visual laws of art. Schwitters' late landscapes bear witness to an enormous sureness in the division of the picture surface, in the setting of focal points, and in the conception of transitions – experiences that played an equally decisive role in the production of Merz pictures. These experiences were gained and employed in both areas of his work.

MERZ PAINTING
–

Schwitters explained his novel approach and the aim of Merz painting in detail on the occasion of the first exhibition of his Merz pictures in 1919. This method, he claimed, made use not only of paint and canvas, of brush and palette, "but of all materials perceptible to the eye and of all the necessary tools. In this it is irrelevant whether the materials used have been previously shaped for some purpose or not. The pram wheel, wire netting, picture cord and cotton wool are factors equal to that of paint. The artist creates by choosing, distributing and de-forming the materials. The de-formation of the materials can be accomplished solely by their distribution on the picture surface. It is further supported by cutting, bending, covering or overpainting. In Merz painting, the lid of the box, the playing card or the newspaper clipping becomes a surface, the string, brushstroke or pencil stroke becomes a line, the wire netting, overpainting or glued-on sandwich paper becomes glaze, the cotton wool becomes softness. Merz painting strives for direct expression by shortening the path from intuition to the visualisation of the work of art."[40]

In view of radical social changes and technical developments, it seemed almost impossible for Modernism to grasp reality in conventional ways such as by means of a realistic oil painting or in a self-contained novel. As early as 1913, encouraged by the *papiers collés* of Georges Braque and Pablo Picasso, who for the first time had integrated real objects such as newspaper pages into their Cubist still lifes, the French poet Guillaume Apollinaire had recognised: "One can paint with all kinds of things: with pipes, with stamps, with postcards or playing cards, with candelabras, with shreds of oilcloth, with beer foam, [...]".[41] A few years later Richard Huelsenbeck called for an art that would be "the transition to the new joy of real things".[42] This meant a new re-

lationship to reality. The search for inspiration detached from the world or the preoccupation with purely aesthetic problems, such as the questioning of pictorial reality promoted by the Cubists, gave way to the examination of current events. Abstract works do not depict or describe reality, but present reality directly through the materials employed.

Schwitters' Merz art absorbed these developments. Essential for its creation was above all the insight into the indifference of all intrinsic values, as well as the realisation that all materials were in principle equally valid and that "all values only exist in relation to one another".[43] Compositions were created from intuitively chosen, arbitrary materials, in which the interplay of the elements alone is decisive. Their form, nevertheless, is not arbitrary, but is still subject to conventional criteria such as balance, tension, rhythm and dynamics.

Only in isolated cases do Schwitters' Merz works exhaust themselves in "literary shock effects"[44] as do many Dadaist and Surrealist visual works. Reproduced figurative representations are rarely found in the Merz pictures, as these are particularly resistant to being incorporated into an abstract composition. In contrast, the Merz drawings contain cropped sections of text, exposed typographical symbols and individual numerals. In even the smallest picture formats we encounter a variety of biographical and contemporary historical information, especially in the form of printed paper with fragments of headlines and advertisements, cinema and tram tickets, cigar bands and chocolate wrappers. These items unmistakably refer to contemporary historical events, trips and personal preferences. Only in their interplay do the text or image components outline a certain associative framework of content. "Much of the period, much of the atmosphere of Germany at the time," Carola Giedion-Welcker observes, "resonates in these compositions. One senses the years of inflation, in which banknotes were devalued hourly and piled up into senseless rubbish. And it was also the time of hunger strikes, mass revolts and social revolutions in Germany. Kurt Schwitters creates a symbolic expression for this very atmosphere. He does not describe, he does not narrate, he suggests a general climate."[45]

The "scraps of everyday waste"[46] used by Schwitters lose their previous utilitarian function in the context of the work, but none of their semantic content. As used objects they possess a specific reference to the social reality of their time and, as remnants of a modern civilisation, become metaphors for a society

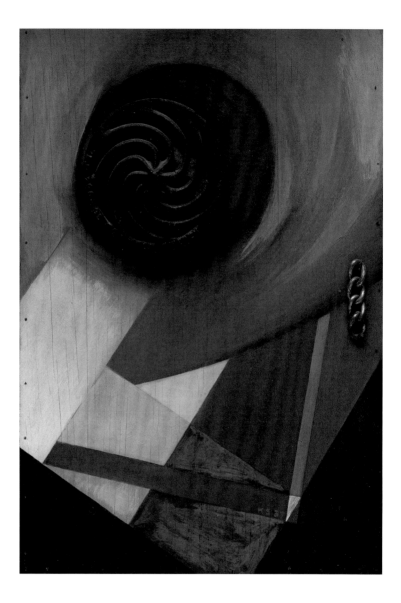

38
MERZ PICTURE WITH CHAIN
1937

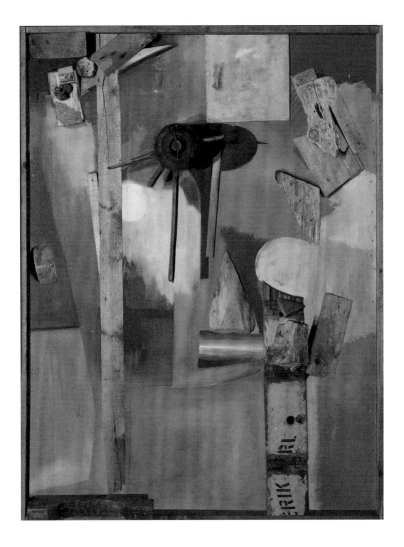

39

UNTITLED (MERZ PICTURE WITH RAINBOW)

1939

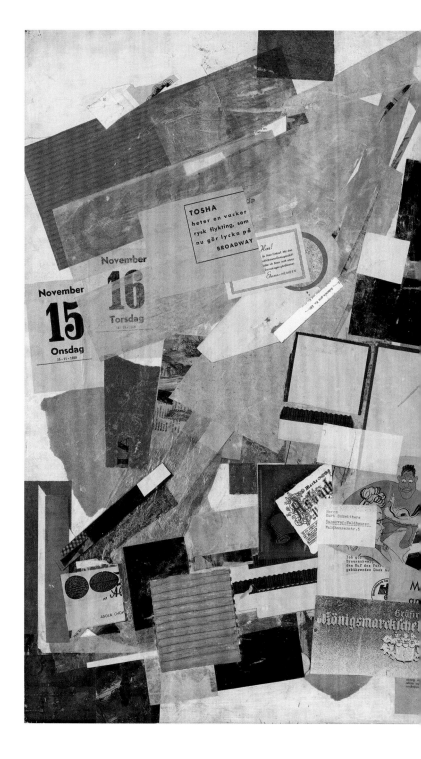

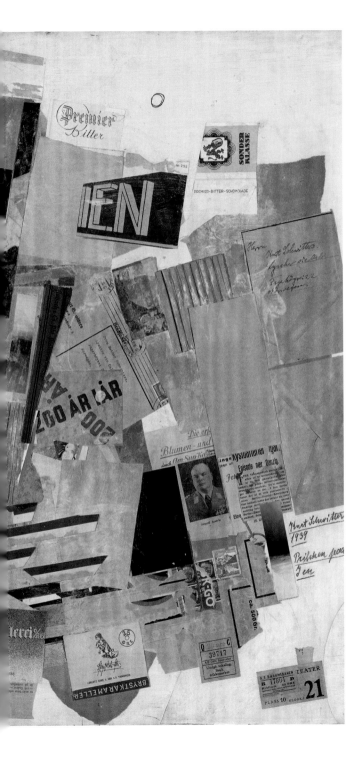

40

DOT ON THE I

1939, collage

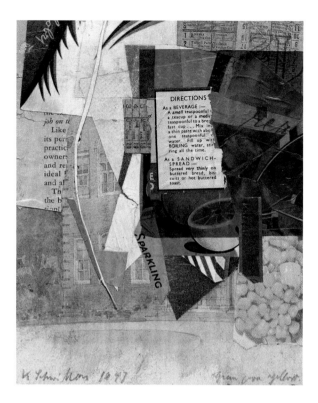

41

GREEN OVER YELLOW.

1947, collage

42

UNTITLED (THE HITLER GANG)

1944, collage

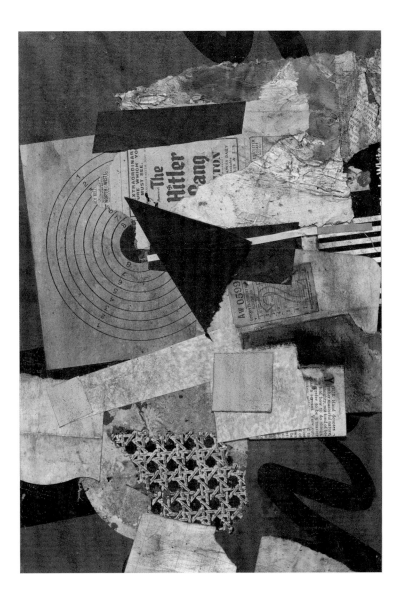

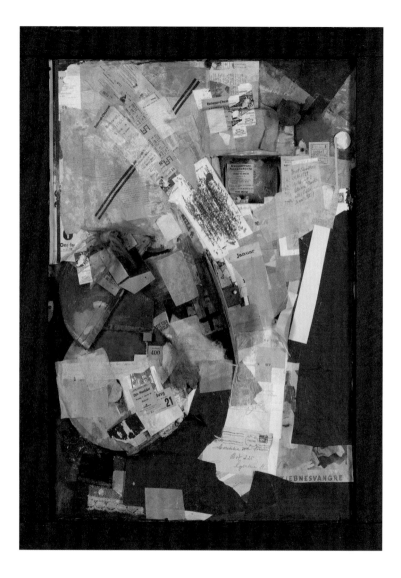

43

PICTURE WITH SPATIAL GROWTHS / PICTURE WITH 2 LITTLE DOGS.

1920 and 1939, Merz picture

that is increasingly characterised by industrial production and consumption, by advertising and the media. There remains a difference whether we perceive a rectangular surface painted over with blue paint, or a blue bus ticket with the usual imprints providing information about the place and date of its original function. On account of the objects used, therefore, an unresolved contradiction remains between Schwitters' proclaimed autonomy of abstract forms with-out a clear semiotic character and the time-related "literary" content of his works. As Julia Nantke recently pointed out, "the assumption of a consistent text strategy or of clearly identifiable textual or pictorial statements in Schwitters' works is misleading." Instead, she aptly describes Schwitters' montages as "unlockable dynamic communication spaces"[47] in which we can move on different levels. It is this dynamism and openness of Merz art that constantly challenges our aesthetic attention.

THE MERZ SERIES
—

The form of an illustrated magazine was the most widespread and common print medium used in Modernism to register a topical international presence in the public sphere. Schwitters too aimed to broaden his sphere of influence when he decided to publish the journal *Merz* in 1923. Its title was also its programme, and he founded his publishing company, Merzverlag, in Hannover specifically for this purpose. The editions followed a concept that transcended media and art forms: in addition to fourteen issues, he also published two lithographic portfolios and a gramophone record (with parts of the *Ursonata*).[48] Schwitters was responsible not only for the content but also for the typographical design. He used the series as a mouthpiece to present all the areas of his multifaceted work in text, image and sound. Thus over the years readers acquired an overview of the development of Merz art and of Schwitters' artistic interests and methods. In addition, the journal served as a strategic instrument for the public positioning of Merz in the European avant-garde field. Initially, this took place primarily within the controversial debate on Dada, but later against the background of the attacks on Modernism and of political polarisation. In the magazines Schwitters related his own works to the artistic discourses and works of other artists, without one-sidedly promoting a particular position as editor.[49]

In *Merz* he published examples chiefly of abstract art, new architecture, modern design, advertising art and artistic photography. They can be assigned to the stylistic trends and leading artist groups of the 1910s and 1920s: Cubism, Dada and Surrealism, Suprematism and Constructivism, as well as De Stijl and Bauhaus. As editor, he chose to focus exclusively on works by those artists he considered important for the advancement of abstraction and the "collective design of the world towards a general style",[50] and who worked "according to individual laws" and "consistently".[51] Thus, Cubist still lifes by Pablo Picasso and Georges Braque stand for a fundamental questioning of pictorial factors and the inclusion of materials foreign to art in painting. Reproductions of collages by his artist friends Arp and Höch emphasise Schwitters' appreciation of this process in particular; at the same time, they highlight his abstract orientation, which focuses the discussion on form rather than on a message. The numerous examples of Constructivist painting proclaim the abandonment of the representational function of the image and testify to an ideal of an art that

KURT SCHWITTERS
REDAKTEUR von MERZ
HANNOVER, WALDHAUSENSTR. 5

44
BUSINESS CARD KURT SCHWITTERS
1923–1929

45
BANALITIES, NO. 4 FROM
THE SERIES MERZ
1923, magazine

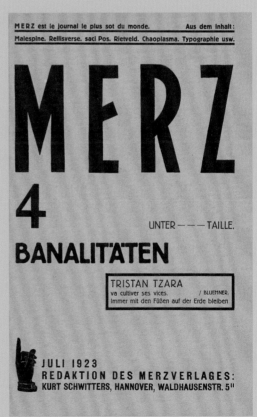

MERZ est le journal le plus sot du monde. Aus dem Inhalt:
Malespine. Rellisverse. saci Pos. Rietveld. Chaoplasma. Typographie usw.

MERZ

4

UNTER — — — TAILLE.

BANALITÄTEN

TRISTAN TZARA
va cultiver ses vices. / BLUEMNER.
immer mit den Füßen auf der Erde bleiben.

JULI 1923
REDAKTION DES MERZVERLAGES:
KURT SCHWITTERS, HANNOVER, WALDHAUSENSTR. 5"

only follows its own laws, such as the effect of colour and space and the weighting of compositional elements. Finally, selected photograms stand for a creative approach to this still new artistic medium, which Schwitters also briefly practised in the late 1920s. The texts presented in the series similarly display a broad spectrum: the prose ranges from aphorisms and advertisements to manifestos and explanations, a novel excerpt and recital text, to grotesques and fairy tales. In addition, the latest forms of poetry such as simultaneous poems, letter poems and sound poems are also found in the journal.

The layout of the first issues is based on Dada publications without a fixed type area, with varying reading direction and different font sizes within a line. Later on, the design of the issues becomes clearer and adheres to the principles of the New Typography: text and image elements are arranged in geometric, often asymmetrically placed areas, whereby the areas – despite a reduction in means – become more dynamic. The Grotesque typeface family was utilised initially; after 1927 Paul Renner's sans-serif, sober-looking Futura was favoured. In the editions from *Merz 12* onwards, the external disparity of the series is particularly striking, as the editor retrospectively declared the four volumes *Hahnepeter, Die Scheuche, Die Märchen vom Paradies* and *Grosstadtbauten* – which had previously appeared in the Apossverlag founded together with Kate Steinitz – to be issues in his series. Economic circumstances, with hyperinflation reaching its peak in 1923, made for the continued publication of *Merz* difficult. As early as the second volume of 1924, Schwitters complained: "Merz is always in deficit. How can you print well without a deficit?"[52] The world economic crisis that began in 1929 led to major hiatuses in publication. Ultimately, however, it was political developments in Germany that prevented Schwitters from continuing the series after 1932.

MERZ ADVERTISING
—

With the start of production of the *Merz* issues, which were produced by hand and letterpress, Schwitters became more intensively involved with typography. Many visual artists worked in the field of advertising at this time, while exhibition institutions (such as the Niedersächsisches Provinzial-Museum) presented printed matter in new typography for the first time to illustrate the "effect of abstract art on everyday life".[53] The boundary between art and design became increasingly permeable in the 1920s. Language, and with it typeface, moved to the centre of artistic production, while typography emerged as an innovative field of the applied arts. Schwitters' founding of the Merz Advertising Bureau in 1924 marked his professionalisation in this field. From then on, under the slogan borrowed from Max Burchartz, "Good advertising is cheap",[54] he offered all the services of a graphic studio, such as "drafts, drawings, printing plates, texts, typography, ideas"; his broad range of products included posters, picture advertising, logos, packaging, catalogues and advertisements, as well as neon signs.[55] In addition to various promotional cards, the Merz advertising business stationery included letterheads, invoice forms and envelopes in very different designs over the years. The logos also changed: the isosceles triangle containing a disc in the middle was followed in 1929 by a stylised lower case "m" consisting of two adjacent curved forms, which appeared in numerous advertisements (fig. 50).

The company was not a registered firm, but Schwitters is listed in the Hannover address books for 1927–1935 under the heading "Gebrauchsgraphiker" [commercial artists] and was also a member of the Bund Deutscher Gebrauchsgraphiker [Association of German Commercial Artists] between 1927 and 1930. As chairman of the "ring neuer werbegestalter" [Association of New Advertising Designers] interest group founded in 1928, he also made a name for himself in exhibitions at the end of the 1920s, particularly as a designer of printed forms and commercial printing. He rightly described himself as an "advertising designer for established companies at home and abroad",[56] because in addition to Hannover-based companies such as Günther Wagner (Pelikan) and Bahlsen, his renowned clients included numerous other industrial companies and institutions, including the Weise Söhne pump works in Halle an der Saale and the Dammerstock-Siedlung architectural project in Karlsruhe directed by Walter Gropius. The sample magazine

46
MERZ ADVERTISING, NOTEBOOK
1924–1927

47
PAGE FROM:
NOTEBOOK MERZ ADVERTISING
1924–1927

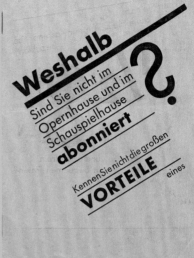

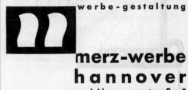

48

SCHOOL REPORT NOTEBOOK FOR MUNICIPAL
GIRLS' SCHOOL III

1930

49

WHY HAVE YOU NO SUBSCRIPTIONS FOR THE
OPERA HOUSE AND THE THEATRE?

1930, brochure

50

ADVERTISEMENT FOR ADVERTISING DESIGN
MERZ-WERBE HANNOVER

1929

"Werbe Merz" [Merz Advertising] designed by Schwitters, for which he reused and glued over a *Merz* journal, contains numerous printed examples of his typographical work and was probably used to show customers when travelling.

Schwitters received his most extensive commission as a typographer in 1929 from the municipal administration of Hannover, for which he designed all printed matter and forms uniformly according to the new DIN format until 1934. He now titled himself – with promotional effectiveness – the "artistic advisor of the city of Hannover".[57] The functional design had to be in line with modern standards and meet other requirements such as the use of type-writers. This facilitated communication, improved the control of work pro-cesses, and thus contributed to a rationalisation of the increasing administrative tasks. Until the turnaround under the National Socialists in 1933, the standard for a uniform appearance was the use of the Futura sans serif typeface, whose clarity and economy were considered contemporary. The obligatory city coat of arms designed by Wilhelm Metzig in the form of a stylised clover leaf was another feature of the new municipal corporate identity. The forms designed by Schwitters for more than a hundred individual offices range from the cremation certificate of the municipal cemetery to the request for seizure from the finance department and the school reports from the municipal schools (fig. 48). For the city's theatres Schwitters designed advertising bro-chures such as the one with the slogan "Why have you no subscriptions for the opera house and the theatre?" (fig. 49). Here he was able to act in a less strictly, uniformly and functionally ordered way than in the official forms. The pages contain various fonts, conspicuously oversized characters and diagonal settings, which reveal the influences of the internationally leading typographers Jan Tschichold and Piet Zwart.

ANNA BLUME

Schwitters' works are "conceived from the quality of performativity – regardless of whether they are only looked at, read, heard or discussed"; they require of us a permanent "alertness and above all the adoption of a perspective".[58] This is particularly evident in the poem *An Anna Blume* [Ann Blossom has Wheels], probably the artist's best-known written work and one that has enjoyed remarkable resonance.[59] Thanks not least to an extensive advertising strategy launched by the publisher that stirred up a public sensation, it suddenly multiplied the author's fame. In 1920 it could be read as a poster on advertising pillars in Hannover. The size, colour and typeface corresponded to announcements for political rallies, thus signalling at the same time "Attention, important message" and arousing false expectations in those who read it (fig. 53). Among conservative critics Schwitters was henceforth considered an insane nonsense poet, although as early as February 1920 the *Kölnische Volkszeitung* recommended – albeit with an ironic undertone – "Anna Blume, you great unknown, you deserve to be in the reading books of the new Germany."[60] Today the poem belongs to the canon of Dadaist love poetry and can indeed be found in numerous schoolbooks.

The text immediately arouses our interest through visual and content-related moments of irritation. The address in the title and in the first line ("Oh thou, beloved…") "opens a dialogue between an 'I' and a 'you'",[61] while we can consider whether we belong to the "people" mentioned in the poem, or whether we can claim the following, supposedly logical prize question for ourselves. In addition, Schwitters constantly unsettles expectations of sophisticated poetry and provokes our inner resistance with grammatical mistakes, misalignments of content and questionable semiotic connections. The poem lives from the contrast between nonsense and plausibility, abstraction and concretion, art and anti-art, and at the same time continuously resolves them by interlocking them linguistically in the closest possible way. In this way, the text demonstrates constant movement and change, as well as the fundamental incompleteness and potentiality of the creation of meaning.[62]

Schwitters included the poem in his earliest independent publication, *Anna Blume. Dichtungen* [Ann Blossom. Poems], which appeared at the end of 1919 in the avant-garde series *Die Silbergäule*, published by Steegemann Verlag in Hannover (fig. 52). It was only there that he declared it programmatically to be

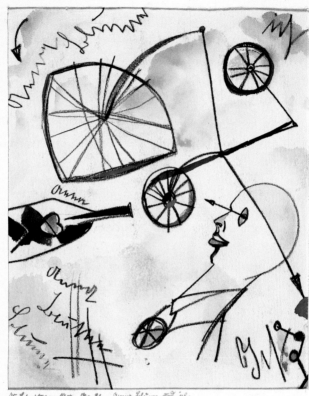

51

AQ. 21. ANN BLOSSOM AND I

1919, watercolour

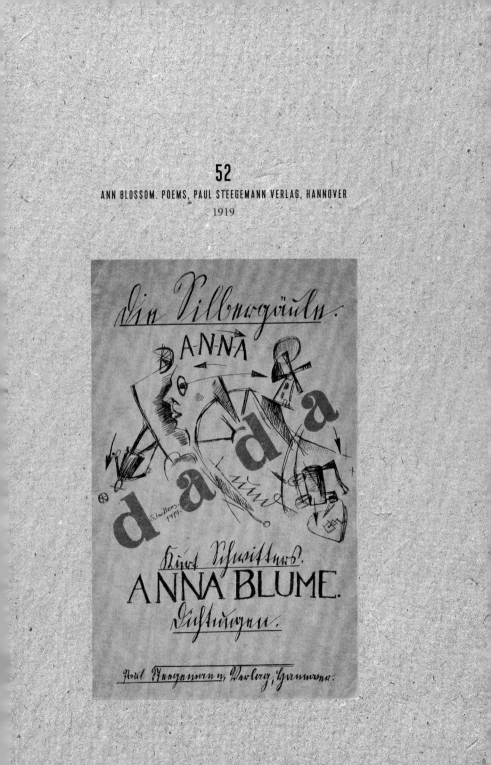

An
AnnaBlume

O du, Geliebte meiner siebenundzwanzig Sinne, ich liebe dir! – Du deiner dich dir, ich dir, du mir. – Wir?
Das gehört (beiläufig) nicht hierher.
Wer bist du, ungezähltes Frauenzimmer? Du bist – – bist du? – Die Leute sagen, du wärest, – laß sie sagen, sie wissen nicht, wie der Kirchturm steht.
Du trägst den Hut auf deinen Füßen und wanderst auf die Hände, auf den Händen wanderst du.
Hallo, deine roten Kleider, in weiße Falten zersägt. Rot liebe ich Anna Blume, rot liebe ich dir! – Du deiner dich dir, ich dir, du mir. – Wir?
Das gehört (beiläufig) in die kalte Glut.
Rote Blume, rote Anna Blume, wie sagen die Leute?

Preisfrage:
1. Anna Blume hat ein Vogel.
2. Anna Blume ist rot.
3. Welche Farbe hat der Vogel?

Blau ist die Farbe deines gelben Haares.
Rot ist das Girren deines grünen Vogels.
Du schlichtes Mädchen im Alltagskleid, du liebes grünes Tier, ich liebe dir! – Du deiner dich dir, ich dir, du mir, – Wir?
Das gehört (beiläufig) in die Glutenkiste.
Anna Blume! Anna, a-n-n-a, ich träufle deinen Namen.
Dein Name tropft wie weiches Rindertalg.
Weißt du es, Anna, weißt du es schon?
Man kann dich auch von hinten lesen, und du, du Herrlichste von allen, du bist von hinten wie von vorne: „a-n-n-a".
Rindertalg träufelt streicheln über meinen Rücken.
Anna Blume, du tropfes Tier, ich liebe dir!

Dies ist eine Probe aus dem schönen Buche „Anna Blume" von Kurt Schwitters
Es ist in allen Buchhandlungen vorrätig. Jeder Gebildete sollte es besitzen. Mk. 4.80

53
TO ANN BLOSSOM, POSTER PAUL STEEGEMANN VERLAG, HANNOVER
1920

Merz Poem 1, thus marking a new artistic beginning in contrast to his previous Expressionist texts, which were based on the so-called word art of the poet August Stramm. In the following years, the name Anna Blume was to develop into a kind of alter ego of the artist and fulfil a similar identificatory function to the sign Merz, with which he was closely connected, indeed almost interchangeable. Like the word Merz, Anna Blume initially appeared as a pictorial element, namely in the inscription "Anna Blume is daft", which the artist is said to have discovered on a fence post.[63] In the drawing *Aq. 21 Ann Blossom and I*, likewise created in 1919, the author and draughtsman appears in a stiff collar and with a rotating Dada wheel on his chest, so to speak, as himself (fig. 51). Opposite him, the handwritten name of the female counterpart in Sütterlin script appears three times as a graphic sign in the picture. The watercolour with its Dadaist-chaotic formal language expresses the restlessness and eagerness to experiment of that time and presents a world that has become unhinged, in which laws such as gravity or perspective no longer apply. Set pieces of a world in which restless movement prevails populate an undefined pictorial space: wheels rotate, mechanical joints spread out, and glances shoot like arrows. Up to 1923, Schwitters produced dozens of works in which the name Anna Blume appears as a quotation, as a sticker, or in the title, and served pars pro toto for the propagation of his Merz art. In 1922, the same publisher brought out a follow-up volume with the same title, which also included various translations of the famous poem – proof of its now international dissemination. The two further volumes of texts by the author published in the same year similarly exploited the well-known name in their titles with great advertising appeal. It is not surprising that *Merz Poem 1* remained of great importance to Schwitters throughout his life. Even while in exile in England, he noted down translations and a few months before his death, worried about the lack of copies in German, wrote down versions from memory.

I ART
—

Unexpected possibilities opened up for Schwitters when he expanded the concept of material through the quotation. As in the case of the pictorial collages, elements that were banal and alien to art became equally important materials for text production from *Merz poem 1* onwards. Using found sentences such as instructions or phrases that could be picked up on a tram or in a stairwell, immediately brought more reality and reference to the times into a work than any description could provide. Yet Merz poetry remains abstract,[64] for, as Schwitters emphasises, the materials are "not to be used logically in their representational relationships, but only within the logic of the work of art."[65] In issue 4 of his *Merz* journal the author collected a whole series of quotations under the heading "Banalities" and shaped them solely through "juxtaposition and evaluation".[66] These include advertising slogans, proverbs and literary aphorisms from the educated middle-class canon, as well as everyday phrases and quotations from his own previously published texts.

Schwitters defined this compilation as a consistent further development of his so-called "i-Kunst" ["i-art"], a "special form of Merz",[67] which had been created in image and text form since 1920 and, like Merz, was conceived across media and art forms. On the whole, the group of works of i-art is relatively small and little known, although the concept on which it is based embodies perhaps the most radical aspect of Merz art. This is because the works are no longer created through the usual mode of production, but solely through the act of finding and recognising them in areas outside art and declaring them as artworks by means of cropping and placement. The reduction of the artistic act is enormous: "The only act of the artist in i is deformulation by limiting a rhythm."[68] The individual vowel, apparently taken from a schoolbook written in Sütterlin script, is already considered an i-poem. It is included in Schwitters' volume *Elementar. Die Blume Anna. Die neue Anna Blume* [Elementary. The Blossom Ann. The New Ann Blossom] from 1922, constructed from typesetting elements. Here the writing process is "performatively staged",[69] where image, voice and writing coincide in the reading instructions ("up, down, up, a little dot on it"). For the *pornographic i-poem*,[70] Schwitters claimed to have cut up a children's song about a goat "lengthwise".[71] The lines break off each time before a vertical line, creating a completely new rhythm. The incomplete words and lines, moreover, draw

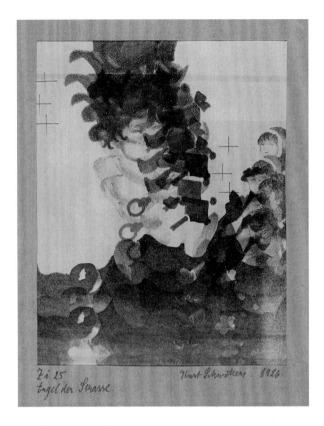

Das i-Gedicht

(lies: „rauf, runter, rauf, Pünktchen drauf.")

54
Z I 25 ANGEL OF THE ROAD
1926, i drawing, misprint

55
THE I POEM
1922 (aus: Kurt Schwitters,
(from: Kurt Schwitters, Elementary.
The Blossom Ann. The New Ann
Blossom. A Collection of Poems from
the Years 1918–1922,
Verlag Der Sturm, Berlin 1923*)*

our attention abruptly to previously hidden content and to new layers of meaning of the supposedly harmless verses.

The "i-drawings" are visual works on paper, mostly consisting of misprints, created out of the waste paper resulting from the rolls of paper passed through printing presses several times to clean them. In the rubbish heaps of the Molling printing works in Hannover, where Schwitters also printed his own works, he found random products such as the sheet *Z i 25 Angel of the Road.* (fig. 54). In this case, we know that it derives from the printing of Amanda Sonnenfels' picture book *Kinder-Paradies* [Children's Paradise],[72] whereas the original context for the majority of i-drawings remains unknown. The misprints, as in this case, often show blurred forms and rhythmic superimpositions and thus a degree of abstraction that is reminiscent of stylistic devices of Cubist or Futurist pictures that optically produce movement on the surface. I-art can be seen as Schwitters' own version of the ready-made: the declaration of an already fabricated picture or existing text as a work of art, as Marcel Duchamp had done shortly before for the first time with the legendary objects *Bicycle Wheel* (1913) and *Bottle Rack* (1914).

MERZ POETRY
—

Schwitters' texts encompass all literary genres and genres, and his cross-medial production continually transcends the boundaries of conventional attributions and thus calls them into question. The transitions between art and literature are also fluid in his work. A clear distinction between where a text ends and an image begins can no longer be drawn. His oeuvre includes collages mounted and signed as pictorial works that consist exclusively of lines of glued-on letters (fig. 58), as well as drawn compositions entitled "set poems" (fig. 57). In his abstract poetry, Schwitters elevates the linguistic material itself to the status of an object, exploring both its visual and tonal qualities. In the early 1920s, inspired by Rudolf Blümner and other Sturm poets as well as the Dada artists in Zurich, who had been performing sound and simultaneous poetry at the Cabaret Voltaire since 1916, he created word, letter and number poems. This so-called "consistent poetry" resulted from a return to the elementary level of language and a reduction of the means of

expression, in order to arrive ultimately at an art free from preconceived content.

The pictorial poems are arrangements of letters, numbers and geometric forms in a limited space and aim primarily at a visual effect,[73] while other elementary poems are primarily designed for acoustic presentation. Individual letters, which themselves are not sounded, provide the opportunity for them to be evaluated aurally by a performer.[74] Since the interpreter's mother tongue influences the result, in 1924 Schwitters added specific instructions for pronunciation to the letter poem *W W:* consonants without vowels are voiceless and can be spoken as in German, whereas vowels are very short and double vowels long instead of being recited twice. It is uncertain whether this also applies to the sound poem *bii büll ree*, written in 1936, which has been preserved on an unusually large single sheet (compared to Schwitters' other surviving manuscripts; (fig. 56). What is striking here is the connection between the individual verses and their structuring: the text is not to be read in a linear fashion, but by means of a designated system of references that makes apparent how clearly Schwitters constructed the poem and structured it rhythmically.

Sound poetry overrides the usual function of language. It frees it from logic, semantics and grammar and instead focuses on tonal and rhythmic aspects, the genuinely musical parameters (or, when printed, the typographical arrangement) of the linguistic elements. Sound sequences like "bille bülle ree foo" or "kekkepebber kikke pebber" sound to our ears like a foreign language whose meaning remains incomprehensible. It is possible that Schwitters was inspired by Swedish in this case, since he had visited Stockholm shortly before. In his few texts written in Norwegian and English in exile from 1937 on, we can at least observe how he learned the new language initially via its sound.[75] The *First Symphony on Hjertøya*, a dialogue between an inhabitant of the small island of Hjertøya in the Moldefjord (where Schwitters had a hut that he used as his holiday home) and his dog Vamos, is comprehensible in its acoustic quality of constant word and sentence repetition even for readers who do not speak Norwegian.

From the mid-1920s onwards, Schwitters turned increasingly to traditional narrative forms. From 1922 on he wrote more than twenty plays and scenes, including several comedies and dramas, a piece for "movement speech chorus" and a film sketch, which were aimed at a broad audience and also employed the revue form popular at the time. However, only a few were performed during his lifetime and only four of the plays had been published by 1977,

56
SOUND POEM (BII BÜLL REE ...)
1936, manuscript

57
SET VISUAL POEM
1922 (aus: Kurt Schwitters,
(from: Kurt Schwitters, Elemen-
tary. The Blossom Ann. The New
Ann Blossom. A Collection of
Poems from the Years 1918–1922,
Verlag Der Sturm, Berlin 1923)

Gesetztes Bildgedicht

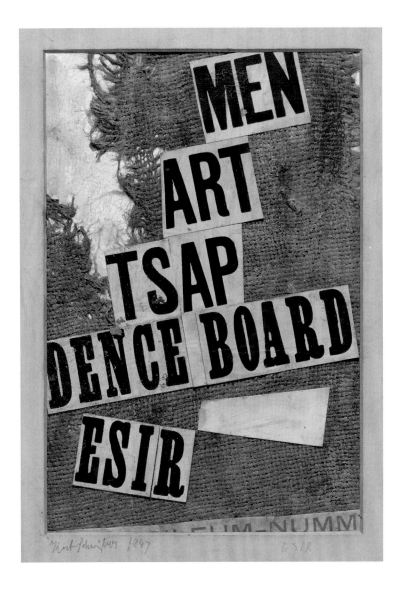

58

ESIR

1947, collage

almost thirty years after his death. He also published – if nothing else, to earn money – prose texts such as grotesques and fairy tales in daily newspapers.

Among his few independent publications is the book *Auguste Bolte (ein Lebertran). Tran Nr. 30* [Auguste Bolte (A Cod Liver Oil). Tran No. 30], published in 1923, which he calls a "symbol for good 'Kkunstkkritik' [art criticism]",[76] whose text is developed from the system of language. The grotesque plot is a "story of statements that have become independent".[77] The behaviour of the protagonist Auguste, who sees ten people walking "straight ahead in one and the same direction" on the street and concludes that "something must be going on there",[78] is based on an insistent illusory logic. As she clings to the (absurd) paradigms once they have been set, she inevitably finds herself in an increasingly fatal situation in her search for the confirmation of her theory, namely the following of the people she sees. By means of increasingly comic words and situations, Schwitters demonstrates how inadequate methods of interpretation – or stubbornness – lead to a hopeless situation.

Similarly, the author foils the literary illusion in his fairy tales from the 1920s and 1930s, which as a narrative form are no exception in the literature of the Weimar Republic. Authors such as Joachim Ringelnatz, Mynona (Salomo Friedlaender), Kurt Tucholsky and Alfred Döblin devoted themselves to this genre. Schwitters deliberately undermines the ideas usually associated with the genre, making his fairy tales not only tragicomic stories with often contemporaneous references to man's futile search for meaning, but always a "reflection on the expectation of what art is and what it achieves"[79] as well. The *Märchen vom Paradies* [Fairy Tales of Paradise], published together with Kate Steinitz, are no longer about princesses and kings, but instead adopt the environment of the bourgeois child as their starting point. Schwitters' narrative style seems to follow directly the unfettered imagination of the child, which always succeeds effortlessly in bridging the obvious gap between reality and imagination. He describes how the miraculous suddenly penetrates everyday life and demonstrates how free association and imagination can trump social conventions and repression. His fairy tales reflect his examination of social, artistic and political themes and expose socially conditioned contradictions and false claims to authority relentlessly, but without a programmatic orientation. They convey a notion of the liberating power of art and of possible changes in existing ways of living and thinking.

URSONATE

—

Schwitters' *Ursonate* [Ursonata] is considered the most extensive and complex work within modern sound poetry. It was created at the interfaces of poetry, music, typography and performance and is conceived as a multimedia Gesamtkunstwerk spanning the art forms. It is not only for this reason that the artist considered it as one of his two "life's works"[80] alongside the *Merzbau*, regarding it as his "most comprehensive and important poetic work".[81] Using linguistic elements such as "Rinnzekete bee bee nnz krr müüüü" or "Lanke trr gll", he created a unique musical notation, a sound structure composed of phonemes, whose fixed sequence is based on the classical sonata form and includes an exposition, various themes with elaborations, a recapitulation, and a cadenza.[82]

As is well known, by 1921 at the latest, Raoul Hausmann's letter poem *fmsbwtözäu*, which Schwitters made the main theme of the first movement, was the initial spark for the further development of a work marked by a desire for experimentation as well as formal consistency, driven primarily by constant recitation. As early as 1923, he planned a *Sonate in FMS* (duration fifteen minutes) for a Merz evening in the Deutsches Haus in Braunschweig, but outside the scheduled programme and only for "good-hearted and musical visitors".[83] By 1927 almost all the themes of the piece had been developed and were published as partial publications in international journals. Finally, in 1932, Tschichold set the full score and printed it as the last issue in the *Merz* journal series (fig. 59). On the whole, though, Schwitters worked for over twenty years continuously on the piece, even on a version influenced by English while in exile in London. In September 1923 and in May 1932 he recorded parts of the Ursonata on gramophone records and on 27 May 1930 he spoke it live on the radio station SWR Frankfurt. At the end of the 1920s he staged a performance for a film, which is the only known film recording of the artist ever made.[84] It is a three-minute silent film sequence by Paul Schuitema, probably made in Holland as a rehearsal or private shooting under improvised conditions. It is evident that it is not a recording of a recital, but an "artistically planned speech situation for the film camera, in a staged setting and with a differentiated mimicry of the spoken text."[85]

As early as 1927, immediately following the completion of the written version, Schwitters began attempts to create a musical equivalent to the text version.

He was not content with a composition for one voice produced by linguistic means, but also wanted to define the spoken sounds in terms of musical sound. His estate contains various musical notations, all of which have remained fragments and have only recently been catalogued.[86] They seek to notate the sounds, rhythm, volume and pitch in a more precise way than sequences of letters with explanatory notes can do. Above all, the sheet music written in exile in Norway from 1937 onwards bear witness to the artist's repeated preoccupation with compositional theory, which he needed for his plan "to also compose it for piano in accordance with the sound sonata".[87] In internment in England he continued his studies of harmonic theory once again, although he obviously struggled with his inability to compose.[88] As early as 1937, and also after the Second World War, Schwitters hoped to have an opportunity to produce a complete recording of his approximately thirty-five minute performance, for the two recordings mentioned above, distributed as No. 13 in the *Merz* series, present only short excerpts. Moreover, as the author noted, the writing alone would only "allow a very incomplete indication of the spoken sonata". It would be better, he believed, to listen to the work than to read it. His early death in 1948, however, foiled the plan of handing down to posterity an aural impression of the complete piece.[89]

dritter teil:

scherzo
(die themen sind karakteristisch verschieden vorzutragen)

Lanke trr gll *(munter)*	**(M)** III 8
pe pe pe pe pe	
Ooka ooka ooka ooka	
Lanke trr gll	III 9
pii pii pii pii pii	
Züüka züüka züüka züüka	
Lanke trr gll	III 4
Rrmmp	
Rrnnf	
Lanke trr gll	III 3
Ziiuu lenn trll?	
Lümpff tümpff trll	10
Lanke trr gll	III 4
Rrumpff tilff too	
Lanke trr gll	III 3
Ziiuu lenn trll?	
Lümpff tümpff trll	10
Lanke trr gll	III 8
Pe pe pe pe pe	
Ooka ooka ooka ooka	
Lanke trr gll	III 9
Pii pii pii pii pii	
Züüka züüka züüka züüka	
Lanke trr gll	III 4
Rrmmp	
Rrnnf	
Lanke trr gll	

172

trio *(äußerst langsam vorzutragen.)*

Ziiuu iiuu	**(N)** 3
ziiuu aauu	
ziiuu iiuu	
ziiuu Aaa	
Ziiuu iiuu	3
ziiuu aauu	
ziiuu iiuu	
ziiuu Ooo	
Ziiuu iiuu	3
ziiuu aauu	
ziiuu iiuu	

scherzo

Lanke trr gll *(munter)*	**(O)** III 8
pe pe pe pe pe	
Ooka ooka ooka ooka	
Lanke trr gll	III 9
Pii pii pii pii pii	
Züüka züüka züüka züüka	
Lanke trr gll	III 4
Rrmmp	
Rrnnf	
Lanke trr gll	III 3
Ziiuu lenn trll?	
Lümpff tümpff trll	10
Lanke trr gll	II 4
Rrumpff tilff too	
Lanke trr gll	III 3
Ziiuu lenn trll?	
Lümpff tümpff trll	10

173

59
URSONATA, NO. 24 FROM THE SERIES
MERZ (THIRD SECTION: SCHERZO),
1932

60
URSONATA
1938–1939, score

61
KURT SCHWITTERS PERFORMING
HIS URSONATA
London, 1944 (Photo: Ernst Schwitters)

62
INVITATION TO MERZ EVENING
1923/24

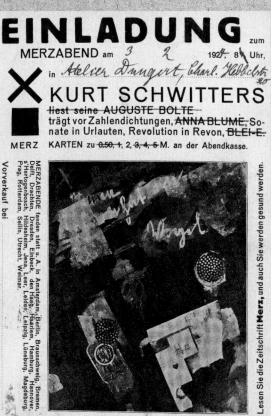

EINLADUNG zum
MERZABEND am 3 2 1924, 8 Uhr,
in *Atelier Dungert, Charl. Hebbelstr.*

KURT SCHWITTERS
liest seine AUGUSTE BOLTE
trägt vor Zahlendichtungen, ANNA BLUME, So-
nate in Urlauten, Revolution in Revon, BLEI-E.
MERZ KARTEN zu 0.50, 1, 2, 3, 4, 5 M. an der Abendkasse.

MERZABENDE fanden statt u. A. in Amsterdam, Berlin, Braunschweig, Bremen, Delft, Drachten, Dresden, Einbeck, den Haag, Haarlem, Hamburg, Hannover, s'Hertogenbosch, Hildesheim, Jena, Leer, Leiden, Leipzig, Lüneburg, Magdeburg, Prag, Rotterdam, Stellin, Utrecht, Weimar.

Vorverkauf bei

Lesen Sie die Zeitschrift **Merz**, und auch Sie werden gesund werden.

KURT SCHWITTERS „Das Kreuz des Erlösers" 1919, Sammlung Walden, Berlin.

MERZ PERFORMANCE EVENING
—

Along with the poem *Ann Blossom has Wheels* and prose texts such as *Auguste Bolte* and *Ursachen und Beginn der grossen Revolution in Revon* [Causes and Beginning of the Great Revolution in Revon], the *Ursonata* was part of the standard programme of Schwitters' numerous appearances as a performer. As a "master of the dramatic pause, of tension, emotional excitement and liberating laughter",[90] he knew how to perform his work successfully, transforming the audience "into participating actors in interaction with him".[91] The performance evenings held since 1920 formed a significant part of Merz art and considerably contributed to its dissemination. On journeys through Germany and to neighbouring European countries such as the Netherlands, the Czech Republic, France and Switzerland the artist could be seen at private or public events in museums, art associations and galleries, on theatre and opera stages. Contemporary witnesses testify to Schwitters' "room-filling"[92] stage presence and that in everything he seemed "to succeed easily and as a matter of course".[93] The sound and letter poems especially, which had to be performed[94] and vocally enunciated, required a great capacity for differentiation and great vocal volume from the performer. Schwitters emphasised that poetry was only material for the performance and that "it is even indifferent" whether this material was poetry or not. Even the alphabet, which was originally a purely functional form, could be recited in such a way that "the result becomes a work of art".[95] The artist Werner Graeff recalls that Schwitters was able to "walk onto the podium with literally nothing in terms of material, and through the natural confidence of his appearance, the precision of his few introductory words and the unmistakable art of his sound composition, he immediately captivated and excited even a hostile audience."[96]

The most frequent reaction of the audience to absurd-sounding sound sequences or bizarrely running stories was to laugh together, the first step in a possible liberation from conventions and constraints. His performances had this cathartic effect especially in the camp on the Isle of Man in the Irish Sea, where Schwitters was interned while fleeing from the Nazis in 1940/41. His performance of the one-word poem *Silence*, which is exclusively recounted in reports, is legendary. Beginning very quietly, he recited the word "silence" with constantly increasing volume, which grew into a wild screaming and culminated in the smashing of a porcelain cup – a rebellious act that, given the

lack of such valuable utensils in the camp, was tantamount to sacrilege, and because of its supposed senselessness, together with the grotesque parody of the screamed word "silence", was at once an act of protest and of liberation.[97]

MERZ STAGE
—

Closely related to the Merz lecture evenings aimed at incurring shock and stimulating exhilarating provocation is the effect of the Gesamtkunstwerk "Merzbühne" [Merz stage]. Schwitters' utopian design of 1919, which as a "poetic collage radically based on material aesthetics"[98] adheres to the basic principles of the Merz concept, belongs in the context of the manifold efforts of avant-garde artists to fundamentally renew the theatre. The *Merz stage* was one of the first to break "with all the theatrical dispositives of the time".[99] What is special here is that the concept of material is extended to include the spectator, that is, producer and recipient are on an equal footing in the process of creating the performance. The theatre, moreover, becomes independent of the poet. He or she is replaced by "the Merzer, the creator of the Merz stage work",[100] "who has to react spontaneously and without preparation to the various events and statements from the audience."[101] The performances were to evolve into an artistic form solely from the material available, such as stage, scenery, colour, light, actors, director, painter and audience, in an interactive process, whereby a strict plot is deliberately avoided.

Influenced by the Bauhaus theatre and projects by Russian artists such as Kasimir Malevich and El Lissitzky, Schwitters designed another stage concept after 1924 titled the *Standard Merz Stage*, which has nothing in common with the poetic *Merz stage* of 1920. On the contrary, it is characterised by simplicity and practicality, thanks to its reduction in technical complexity. Here a backdrop is used for the performance of stage works and is intended to enhance their expressiveness in space. The stage consists of basic geometric shapes such as cuboid, sphere and cube, which are painted monochrome black, grey and red. Arranged within a functional staggering of depth, these elements can be moved flexibly and allow for quick scene changes. Photographs of the wooden model of this proscenium stage show possible

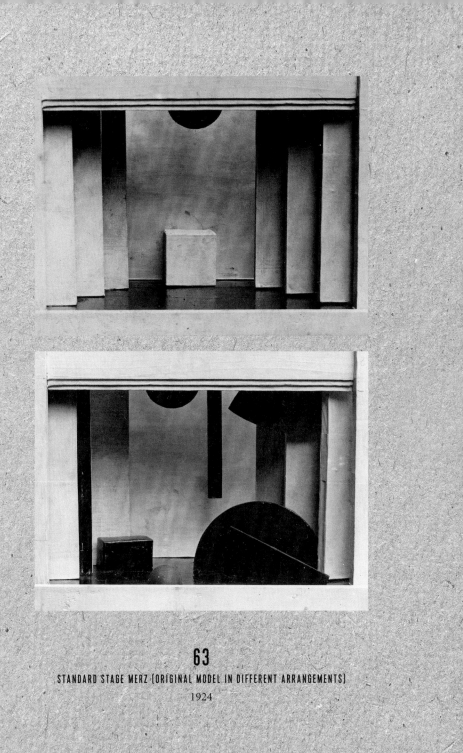

63

STANDARD STAGE MERZ (ORIGINAL MODEL IN DIFFERENT ARRANGEMENTS)

1924

variations of the arrangement (fig. 63). It was displayed in 1924 at the "International Exhibition of New Theatre Technology in Vienna", organised by Friedrich Kiesler, and later in Paris and New York. As a corrective to this, in a drawing from 1925 Schwitters designed a spatial stage that could be viewed and walked on from all sides and was closer to the surrounding auditorium. All of his stage concepts remained merely aesthetic statements; they were never realised in the theatre. In the 1920s municipal theatres in provincial capitals such as Hannover usually presented a cultivated literary and educational theatre, tending not to foster avant-garde experiments.

MERZ ARCHITECTURE
—

Schwitters was not an architect: he did not design buildings and never had his own house built. He himself lived with his wife Helma and son Ernst in a flat in his parents' apartment building, which had been erected in Wilhelminian style on the outskirts of Hannover in the early twentieth century. From 1927 on, a room in his parents' apartment on the mezzanine floor was available to him as a studio, in which he created the *Merzbau* [Merz construction] in the following years. Even later during his exile he lived in rather cramped rented apartments in Lysaker (near Oslo), London and Ambleside (Lake District); attics, huts, and barns served him as working spaces. They were always spaces and materials which Schwitters found and to which he reacted. They advanced the process of building and designing, in keeping with the motto "Merz does not want to build; Merz wants to rebuild."[102]

Theoretically, however, the artist – who had studied architecture for two semesters at the Technical University of Hannover in 1917/18 – engaged very intensively as well as critically with architecture, in particular the new architecture of the Weimar Republic. He was in contact with important architects of his time, including Walter Gropius, Ludwig Hilberseimer, and Otto Haesler, and without exclusively defending the general international style, wrote reports on pioneering building projects such as the Weissenhofsiedlung from 1927 in Stuttgart or the Dammerstocksiedlung from 1929 in Karlsruhe.[103] In the *Merz* journal he regularly presented important examples of functional and visionary architecture, which impressively demonstrated the special significance of

64
CASTLE AND CATHEDRAL WITH COURTYARD WELL
1920/1922, Merz architecture

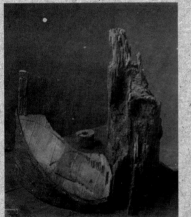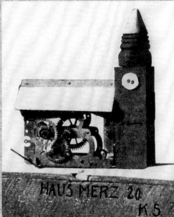

65
MERZ HOUSE
1920, Merz architecture

architecture and its relevance to so many areas of life. Many contemporary artists were convinced that architecture would play a predominant role in the future development of art and society.

In *Merz 1*, Schwitters formulated programmatically: "The most comprehensive work of art is architecture. It encompasses all forms of art."[104] For him, "of all art genres, architecture [...] is most attuned to the idea of Merz", for this, "as is well known, means the use of old things as material for the new work of art"; architects develop their "idea of the new Gesamtkunstwerk"[105] taking into account existing buildings and aspects of urban planning. Accordingly, in addition to Merz architecture, he also called for "the Merz use of architecture for new design".[106] By enhancing the available compositional elements with entire buildings or streets, large cities like Berlin could – if Schwitters had his way – be transformed into enormous Merz works of art (without thinking here of totalitarian transformations). The sculptural assemblages that he called Merz architecture have been lost, including the *Merz House* and the ensemble *Castle and Cathedral with Courtyard Well* (fig. 64, 65). These small sculptures, created around 1920, were made of unspectacular objects such as building blocks, the interior of a clock, or roughly hewn pieces of wood, combined with the perforated cork of a bottle of medicine, which in this case embodied the fountain. These supposedly ingenuous bricolages functioned as architectural models and were intended to stimulate the imagination of the builders. Spengemann described them as "absolute architecture that only has artistic meaning."[107]

MERZBAU
—

The Merzbauten [Merz constructions] erected at Waldhausenstrasse 5 in Hannover and later at other places where the artist lived can be see as the most comprehensive realisation of the Merz idea. They are regarded in art-historical scholarship as the most influential forerunners of installation art, that is, the site-specific, three-dimensional design of spaces. They are the result of Schwitters' lifelong, dynamically progressing work process of aesthet-ically shaping his environment – in reaction to and in exchange with his surroundings, and with the participation of selected persons. The only con-stant in this process is the person of the artist and his Merz idea, which he pursued equally in all three countries. Although – or precisely because – al-most all the Merz buildings have been destroyed and only a few sources on them exist, the history of their impact has acquired almost mythical propor-tions. To this day they continue to impress us as testimony to an unswerving, autonomous artistic position and a steadfastly lived utopia.

The name "Merzbau" [Merz construction] first appeared in 1933 and only later became widely accepted, more than a decade after the beginning of the construction.[108] The three-dimensional structure that developed in the studio embodied something so new that no common or adequate term existed for it. In order to avoid misunderstandings, the artist explained that his work was neither interior design "in a decorative manner, for instance", nor a space "in which one should live", but a work of art, an "abstract (Cubist) sculpture into which one can enter".[109] He described the *Merzbau* as "a flowing structure, the generator of a force field that fluctuates as ones moves round the interior."[110] After its de-struction in 1943, he described it as "my work, so to speak, which I lived for and worked on for ten years."[111] When for political reasons Schwitters left Hannover for ever in January 1937, a total of eight rooms scattered throughout the house were said to have been subjected to "Merz".[112] These included the former bed-room of his parents' flat as the "main room", its adjoining room and the adjoin-ing (glazed) balcony, two cellar rooms, a place in the artist's apartment, and two former maid's rooms on the upper floor.[113] A column grew through one of the dormer windows onto the roof and a staircase led to a platform on the roof ridge, which is said to have been available for sunbathing.[114]

The main room, measuring approximately 20 square metres, was documented in 1933 by photographer Wilhelm Redemann in three wide-angle photographs

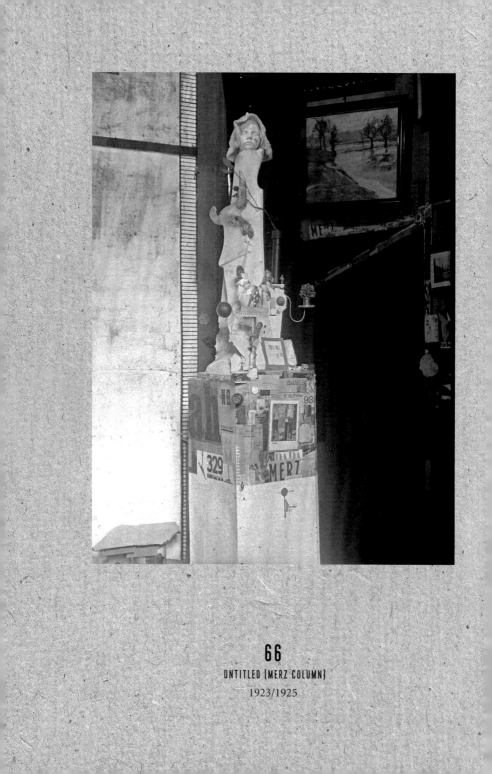

66
UNTITLED (MERZ COLUMN)
1923/1925

(fig. 67). While these photographs were published and exhibited abroad, in Hannover Schwitters tragically had to keep the work hidden from the moment he apparently considered its state worthy of publication, in order to protect it from destruction by the Nazis. From 1933 onwards his works were publicly defamed and his publications burned in the exhibitions of "degenerate art" that they held. In the early 1980s Redemann's photographs were the basis for a replica commissioned by the curator Harald Szeemann from the Swiss set designer Peter Bissegger. Today it is part of the collection at the Sprengel Museum Hannover.

Individual steles like the towering *Merz Column* formed the beginnings of Schwitters' spatial structure (fig. 66). A pedestal was surrounded by printed matter such as advertising leaflets and various objects including the plaster cast of a baby's head, a sconce and branches. In 1927/28 the projecting, over three metre-high *Great Column* was created, also known as the *Cathedral of Erotic Misery*, which one could enter and follow its spiral. With the allusive title, the wordsmith presumably referred to the concept of the "cathedral of the future" that was virulent around 1919, in ironic distance to the Expressionists' ersatz-religious apotheosis of architecture. According to Walter Gropius, this "should be everything in *one* form [...] architecture *and* sculpture *and* painting".[115] In the spirit of the Merzgesamtkunstwerk that he was striving for, Schwitters also united all artistic genres: he combined pictures, objects and sculptures, created collages, painted the relief-like interlocking construction, and shaped numerous "grottos" out of their niches, such as a *Nibelungen Hoard*, a *Sex Murder Cave* and a *Luther Corner*. Each theme was represented by the correspondingly characteristic objects. The private and public, the trivial and the significant for the bourgeois world, history and current events intersected here, whereby the pathos of ideals that had become questionable, such as heroism, bravery and patriotism, was twisted into the grotesque.

The spectacular work of Johannes Baader, which was shown at the "First International Dada Fair" in Berlin in 1920, probably inspired the creation of the Merz columns. The five-storey construction *Plasto-Dio-Dada-Drama "Germany's Greatness and Decline or The Fantastic Life of the Superdada"* was a tower-like construction made of found objects. The fragile accumulation demonstrated an experimental kind of spatial-plastic design that made architecture "an event of the imponderable".[116] The Dadaist construction was a movable structure determined by external influences, not only determined by

67
THE MERZ CONSTRUCTION IN HANNOVER
1933 (Photo: Wilhelm Redemann)

architectonic logic, but also by subjective intuition.[117] The *Merzbau* was similarly based on a comparably open concept of space and architecture. It was not created according to plans, but in a fundamentally on-going, permanently mushrooming process, which can be regarded as a fundamental characteristic of Merz art.

Avant-garde spaces, such as El Lissitzky's *Prounenraum* at the "Berlin Art Exhibition" in 1923 (the first autonomous art space that embodied nothing more than a three-dimensional abstract composition), may have encouraged Schwitters to tackle the making of a spatial sculpture and ultimately to bring the individual columns together to form a unity. The result was a geometric-abstract wooden construction joined with plaster and putty, which grew from the walls into the room and also integrated the ceiling and floor. The large, labyrinthine sculpture was lit by dozens of small, mostly indirectly illuminating electric light bulbs, which enabled lighting with changing atmospheres.[118] Most of the grottos disappeared under the smooth, predominantly white surface, while only a few material accumulations were still visible behind glass. In this way Schwitters relativized the significance of the literary content, which still remained in existence like archaeological deposits and contributed significantly to the multi-layered significance of the *Merzbau*, which enclosed in itself its particular history.[119] Initially a storeroom, studio and private residence, it eventually became a walk-in sculpture open to (private) visitors. It housed an art collection and served as the stage for guided tours by the artist that were like performances. Apart from friends and colleagues, however, only relatively few people were able to enjoy a visit, including the American collector Katherine S. Dreier and the Swiss art historian Carola Giedion-Welcker.

MERZ COLLECTION

The "Merz collection"[120] was located primarily in the *Merzbau* and comprised more than fifty confirmed works of art by over thirty different contemporaries, including Paul Klee, Wassily Kandinsky, Lyonel Feininger and Iwan Puni.[121] They supplied visitors with an impression of the abstract art movements of the 1920s and thus the context in which Schwitters' work was created. As the collector had only limited financial means at his disposal, he presumably acquired many of the works as gifts or in (if necessary, persistently requested) exchange for his own works. A lure for hesitant partners was not least his argument that through his collection he "had already promoted many".[122] Schwitters was careful to acquire works that "fit"[123] into the collection and pursued "the aim of providing orientation about new artistic creation".[124]

Works "not considered part of the Merzbau"[125] were taken by Schwitters into exile in Norway. Like his own works, they survived the war years in Norway and were later largely sold by his son Ernst. Some outstanding pieces are now in public collections. The Museum of Modern Art in New York, for example, houses two works on paper by Lissitzky and van Doesburg which used to hang in Schwitters' living room in Lysaker.[126] Only a small part of the Merz collection remained in the estate (now in the Kurt and Ernst Schwitters Foundation and on loan to the Sprengel Museum Hannover), in particular works by artists with whom Schwitters had contact in Norway and England, including Paul Nesch and Erich Kahn, the Dane Vilhelm Bjerke-Petersen and the Englishman Roland Penrose. The latter organised the exhibition "Twentieth Century German Art" at London's Burlington Gallery in 1938 together with Herbert Read, in which he showed two works by Schwitters.

The internationality and quality of the Merz collection were due to the artist's personal enthusiasm and intuition; for him travel, stimulating contacts and artistic exchange were the elixir of life. The gathering of works from all over Europe can be seen as part of his comprehensive Merz concept, which aimed to create relationships and did not stop at national borders, art programmes or styles.

MERZ CONSTRUCTIONS IN EXILE
—

After leaving Hannover in 1937, Schwitters wrote Dreier from Norway: "What fills me most with sadness is that I cannot live in my Merz space."[127] For the artist, there was no spatial and temporal separation of life and work.[128] The artistic shaping of his working spaces had become an indispensable process for him, which he was to continue with sustained intensity and endurance even under hostile to life-threatening circumstances and despite obstacles in his exile such as danger, lack of money, cold, and, at the end, illness.[129] In the very same year in which he experienced his fiftieth birthday as "forgotten"[130] by the art world, he began work on the second Merzbau in Lysaker near Oslo, the *House on the Slope*. In formal terms it was directly linked to the abstract-constructive form of the *Merzbau* in Hannover. In order to be able to fill the emptiness that still reigned in it more quickly, he asked friends to send him material such as "small texts" and "photos to be 'merzed' in grottos and for the studio book".[131] After the beginning of the war in 1939, he assumed that it would take another eight to ten years to complete the work. However, the escape to England from the German troops that invaded Norway in April 1940 forced the artist to leave his studio behind once again. In 1951 it burned down completely.

In Norway, Schwitters had already begun to "merz" a tiny stone cabin on the island of Hjertøya in Moldefjord that the family had used as a holiday home since 1932. Although he never called it a Merzbau, the interior underwent the same artistic treatment: printed paper and nailed-on found objects transformed the walls into collages and reliefs; in some places wooden struts and niche constructions filled with plaster were created, some painted in the primary colours red, yellow and blue. As always, the artist mainly used materials he discovered in the surroundings. He writes of "wonderful things" on Hjertøya, which the sea washed up and with which he executed "amusing compositions".[132] The "merzed" parts of the cottage, which have since been moved to the Romsdalsmuseet in Molde and restored,[133] are among the few remaining original fragments of a Merz construction. The connection between life and art becomes immediately apparent here when one sees that the collaged walls also contain a ferry timetable and dietary instructions for Ernst Schwitters – probably because of their constant use. This aspect also applies to the travel chest which Schwitters used to transport painting utensils

to Norway and the pictures painted there back to Hannover (fig. 71). It repro-duces the Merz idea virtually in a "travel format". The double-sided collage of the inner partition gives an impression of Schwitters' discovery of his adopted home in Norway and at the same time documents the "export of Merz".[134]

Schwitters began one last Merz construction, the *Merz Barn* on the Cylinders estate of the garden architect Harry Pierce in Elterwalter near Ambleside, in the summer of 1947, a few months before his death, when his health had al-ready severely deteriorated. His creative urge nonetheless remained untiring, driven by the hope of compensating for the loss he had suffered in Hannover and thus preventing his Merz constructions from being forgotten. After years of spatial constraints, he finally had his own space again, which made inde-pendent work and the storage of his works possible and offered a certain amount of public exposure. Only one tenth of the work was completed.[135] We can therefore only imagine to a limited extent how the spatial construction would have been able to grow inside the barn, which had neither flooring nor window panes, electric lighting nor heating. A diagonal corridor between low walls and lowered ceilings with curved bulges and vaults was to lead from window to window. The basic construction disappeared under coarsely filled decorator's plaster, which was then smoothed and painted in different colours. This is shown by the relief wall transferred to the Hatton Gallery in Newcastle in 1965 (fig. 74). Stylistically, its organic formal language differs considerably from the geometric clarity of the surfaces in the earlier Merz constructions. Since the paint was often mixed with plaster, it acquires a greater materiality and creates an optically moving, lively surface.

Apart from the stylistic change, however, Schwitters' approach was not funda-mentally different from his previous one. Here too, in his last major work, he followed his principles, valid since 1919, of creating a work "by the choosing, distributing and deformation of materials"[136] and "building new art forms from the remains of former culture".[137] At Cylinders, he was inspired by the landscape formations of the Great Langdale Valley in the Lake District and the nature of the barn, which is built of slate using the traditional drystone con-struction method. In response to the rough masonry, he adopted a new way of building: he used the spaces in between to fix the elements projecting far into the room, painted existing depressions to create colourful accents, and framed some of the cavities to fill them with small assemblages of material. Today there are few original traces of Schwitters' work left in the barn. The modesty

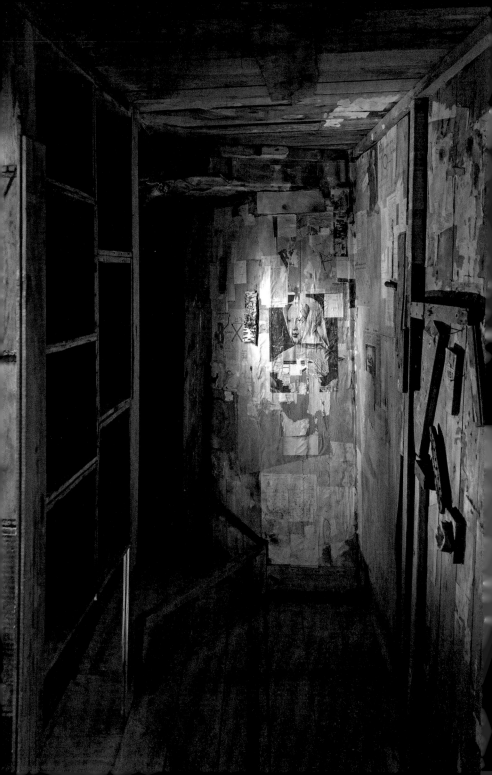

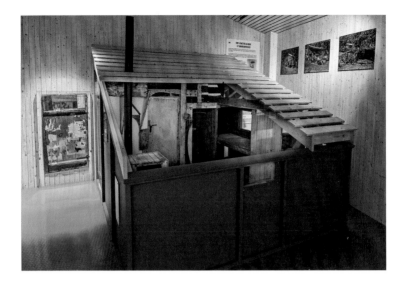

69

HALL IN THE HUT ON HJERTØYA

1932–1939

70

THE HUT ON HJERTØYA

1932–1939, state in 2016,
after transfer to the Romsdalsmuseet, Molde

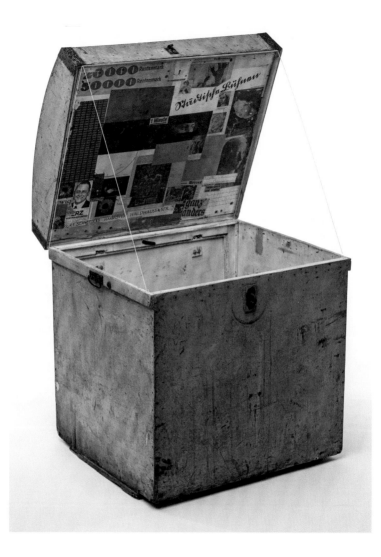

71
TRUNK
1926–1934

and emptiness of the room make it a special place of remembrance of the artist and his poignant fate in exile.

The essence of Merz is freedom and tolerance, relationship and exchange. The Merz constructions, all of which contain an irretrievable part of Schwitters' life and work phases, were especially in moments of external threat a courageous commitment to freedom. By means of the "scruffy remnants of his time"[138] assembled in them, which lend Merz art its critical note, the artist was able to engage with his respective environment and with current events. "Reciprocity, response and feedback were key factors"[139] in the development of his Merz constructions, but also the highest degree of individuality.

All forms of Merz art bear witness to Schwitters' nonconformist, cross-border artistic productivity and his open and resistant mentality, the provocative power of which can still be felt today.

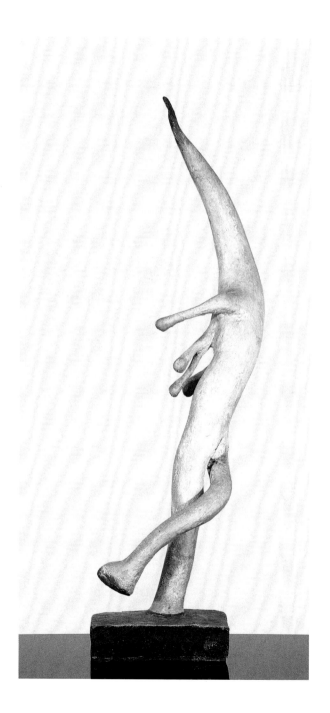

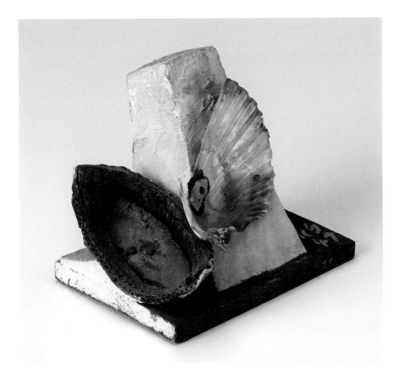

72

DANCER

1943, wooden sculpture

73

UNTITLED (SHELL SCULPTURE)

1947

74
RELIEF WALL IN THE MERZ BARN
1947 (Photo: Ernst Schwitters, 1953/60)

75
UNTITLED (PICTURE WITH TIN AND BAND)
ca.1945, relief

NOTES

1 K. Schwitters, "Merz", 19.12.1920, in *Der Ararat*, II, no. 1, Munich 1921, p. 5.

2 K. Schwitters, "Merz.", in *Pásmo Moderní Leták* [The Zone International Broadsheet], vol. I, issue 4, Prague 1924, title page.

3 K. Schwitters, "Mein Merz und Meine Monstre Merz Muster Messe im Sturm", in *Der Sturm*, vol. XVII, issue 7, Oct. 1926, p. 107.

4 K. Schwitters, "Ich und meine Ziele", in *Merz 21*, 1930, p. 113, see KSAT 4, p. 381.

5 Ibid., p. 114, see KSAT 4, p. 382.

6 K. Schwitters, "Hannover und der abstrakte Raum von Lissitzky", in *Das neue Frankfurt. Monatsschrift für die Probleme moderner Gestaltung*, vol. 3, issue 4 (April), Frankfurt am Main 1929, p. 83.

7 Clement Greenberg, *The Collected Essays and Criticism*, vol. 2: Arrogant Purpose, ed. John O'Brian, New York / Chicago / London: University of Chicago Press 1986, p. 259.

8 Obituary by Hans Arp, in invitation to "Gedächtnisausstellung Kurt Schwitters", Galerie d'Art Moderne Basel, 1948 [reprinted in *Kurt Schwitters. "Bürger und Idiot". Beiträge zu Werk und Wirkung eines Gesamtkünstlers*, ed. Gerhard Schaub, Berlin 1993, p. 135].

9 Roger Cardinal / Gwendolen Webster, *Kurt Schwitters*, Ostfildern 2011, p. 40ff.

10 Ibid., p. 115.

11 Cf. Raoul Hausmann, "Kurt Schwitters wird Merz", in *Am Anfang war Dada*, ed. Karl Riha and Günter Kämpf, Gießen [1972] 1980, p. 63.

12 K. Schwitters, "i (Ein Manifest)", in *Der Sturm*, vol. XIII, 1922, issue 5 (May), Berlin 1922, p. 80.

13 K. Schwitters, "Allgemeines MERZ Programm", 1923, in *"Typographie kann unter Umständen Kunst sein"*, vol. 1: *Kurt Schwitters. Typographie und Werbegestaltung*, ed. Landesmuseum Wiesbaden (Wiesbaden, 1990), catalogue no. 11.

14 K. Schwitters, "Zeitschriften gibt es genug …", in *Merz 1*, 1923, p. 1, see KSAT 4, p. 10.

15 Cardinal/Webster 2011 (see note 9), p. 39.

16 Cf. Julia Nantke, *Ordnungsmuster im Werk von Kurt Schwitters. Zwischen Transgression und Regelhaftigkeit* (spectrum Literaturwissenschaft, vol. 59), Berlin/Boston 2017, p. 394.

17 Cf. Ursula Kocher, "Kartierung virtueller Räume. Zu Kurt Schwitters' Adressbüchern", in *Transgression und Intermedialität. Die Texte von Kurt Schwitters*, ed. Walter Delabar, Ursula Kocher, and Isabel Schulz, (Moderne-Studien, vol. 20), Bielefeld 2016, pp. 119 – 130 and Julia Nantke "Deutschland als 'Merzgebiet'. Kurt Schwitters' subjektive Geografie seines Heimatlandes am Beispiel der Adresshefte", in *Heimat – Räume. Komparatistische Perspektiven auf Herkunftsnarrative*, ed. Jenny Bauer, Claudia Gremler, and Niels Penke, Berlin 2014, pp. 149 – 163.

18 Both quotations in a letter to Friedrich Vordemberge-Gildewart and Ilse Vordemberge-Leda, 22.6.1947, in *Friedrich Vordemberge-Gildewart. Briefwechsel*, ed. Volker Rattemeyer and Dietrich Helms, Museum Wiesbaden and Stiftung Vordemberge-Gildewart in cooperation with the Institut für moderne Kunst Nürnberg, Wiesbaden 1997, vol. 2, p. 242.

19 Letter to Walter Dexel, 15.7.1924, in *Kurt Schwitters. Wir spielen, bis uns der Tod abholt. Briefe aus fünf Jahrzehnten*, ed. Ernst Nündel, Frankfurt am Main/Berlin/Vienna, 1974, p. 84.

20 Letter to Ella Bergmann-Michel, 8.10.1936, Sprengel Museum Hannover, inventory no. A28.02/1936/001.

21 K. Schwitters, "Watch Your Step!", in *Merz 6*, 1923, p. 57, see KSAT 4, p. 132.

22 K. Schwitters, "Merzbuch", 1926, (in *Hamburger Notizbuch*), see KSAT 4, p. 227.

23 Ursula Kocher in KSAT 4, p. 789ff.

24 Ibid.

25 K. Schwitters, "Merzbuch", 1926 (in *Hamburger Notizbuch*), see KSAT 4, p. 227.

26 Katrin Fischer, "Kurt Schwitters: Selbsterfindung und Kunstleben", in *Selbstpoetik 1800 – 2000.*
 Ich-Identität als literarisches Zeichenrecycling, ed. Ralph Köhnen, Frankfurt am Main etc. 2001, p. 204.

27 K. Schwitters, "Merz", in *Die Kunstismen*, ed. El Lissitzky and Hans Arp, Erlenbach-Zurich/Munich/
 Leipzig 1925, p. XI.

28 Meyers Großes Konversations-Lexikon, 1909, quoted in Anke te Heesen, *Der Zeitungsausschnitt.*
 Ein Papierprojekt der Moderne, Frankfurt am Main 2006, p. 200.

29 K. Schwitters, "Kurt Schwitters", in *Gefesselter Blick. 25 Monografien und Beiträge über neue*
 Werbegestaltung, ed. Heinz and Bodo Rasch Stuttgart 1930, p. 88.

30 On the leaflet *Mühlendadaismus Kurt Schwitters*, 1923, in the notebook *8 uur*, see CR, fig. no. 1148.2.

31 K. Schwitters, in *Merz 1*, 1923, p. 4, see KSAT 4, p. 14.

32 K. Schwitters, "Herkunft, Werden und Entfaltung", in *Sturm Bilderbücher IV Kurt Schwitters*, Berlin,
 n.d. (1920), n.p.

33 Schwitters 1920 (see note 1), p. 6.

34 K. Schwitters, "Dadaismus in Holland", in *Merz 1*, 1923, p. 8, see KSAT 4, p. 18.

35 Nantke 2017 (see note 16), p. 391.

36 Cf. CR, no. 1046a, The Moholy-Nagy Foundation, Ann Arbor (Michigan) and CR, no. 1157,
 private collection.

37 Letter to Helma Schwitters, London, 18.3.1942: in Nündel 1974 (see note 19), p. 171.

38 Cf. letter to Katherine S. Dreier, 24.7.1937, in Nündel 1974 (see note 19), p. 137ff.

39 K. Schwitters, in *Merz 20*, 1927, p. 100, see KSAT 4, p. 345.

40 K. Schwitters, "Die Merzmalerei", in *Der Zweemann*, issue 1, 1919, p. 18; also in *Der Sturm*, vol. X,
 issue 4, 1919, p. 61.

41 Guillaume Apollinaire in the chapter on Picasso in *Die Maler des Kubismus* (1913), Zurich 1965, p. 56.

42 Richard Hülsenbeck, "Erste Dadarede in Deutschland", 1918, in *Dada Berlin. Texte, Manifeste,*
 Aktionen, ed. Hanne Bergius and Karl Riha, Ditzingen 1982, p. 18.

43 K. Schwitters in *Sturmbilderbücher* IV, Verlag Der Sturm, no date (1920), unpaginated, before p. 3.

44 Greenberg 1986 (see note 7), p. 262.

45 Carola Giedion-Welcker, "Hans Arp und Kurt Schwitters. Zu einer Doppelausstellung, Rede 1956",
 in idem, *Schriften 1926–1971. Stationen zu einem Zeitbild*, ed. Reinhold Hohl, Cologne 1973, p. 280.

46 K. Schwitters, "Ich und meine Ziele", in *Merz 21*, 1930, p. 115, see KSAT 4, p. 383.

47 Nantke 2017 (see note 16), p. 393.

48 Cf. KSAT 4 and www.schwitters-digital.de.

49 Cf. Ursula Kocher, "Merz und die Avantgarde", in KSAT 4, p. 783.

50 *Merz 1*, 1923, p. 9, see KSAT 4, p. 18.

51 *Merz 6*, 1923, p. 59ff., see KSAT 4, p. 134ff.

52 Letter to Theo van Doesburg, 5.9.1924, in Nündel 1974 (see note 19), p. 88.

53 Alexander Dorner, text panel in *Kabinett der Abstrakten*, photographic reproduction in Sprengel
 Museum Hannover.

54 Cf. *Merz 11*, 1924, title page, see KSAT 4, p. 235.

55 Cf. the advertisement in *Merz 16/17*, 1925, n.p., see KSAT 4, p. 297.

56 Catalogue no. 38 in the catalogue raisonné of the typographical works by Kurt Schwitters
 (ed. Carola Schelle with Maria Haldenwanger), in Schwitters 1990 (see note 13).

57 K. Schwitters in *Gefesselter Blick*, ed. Heinz and Bodo Rasch (Stuttgart 1930), p. 88; cf. also
 Werner Heine, "Der kurze Frühling der Moderne oder Futura ohne Zukunft.

Kurt Schwitters' typographische Arbeiten für die Stadtverwaltung Hannover 1929–1934",
in Schwitters 1990 (see note 13), pp. 92 – 97.

58 Ursula Kocher, "Merz im Dialog – die Herausforderung des Publikums", in "*Schlagkraft der Form*".
Kurt Schwitters. Theater und Typografie, ed. Isabel Schulz (Prinzenstraße, double issue 17),
Hannover 2018, p. 62.

59 Cf. Hans-Jürgen Hereth, *Die Rezeptions- und Wirkungsgeschichte von Kurt Schwitters, dargestellt anhand
seines Gedichts "An Anna Blume"* (Forschungen zur Literatur- und Kulturgeschichte, vol. 53)
(Frankfurt am Main 1996), and Peter Stuck, *Anna Blume, unverblüht. Kurt Schwitters' Dadagedicht
wird 100!*, ed. on behalf of Landeshauptstadt Hannover by Cornelia Regin, Stadtarchiv Hannover,
Hannover, Wehrhahn Verlag 2019.

60 *Kölnische Volkszeitung*, (various reviews) in KSAT 3, p. 604.

61 Kocher 2018 (see note 58), p. 58.

62 I am grateful to Antje Wulff for the summary of her dissertation at the Bergische Universität Wuppertal
(working title: "Rechaotisierungen? Komplexität und nichtlineare Dynamik im Werk von
Kurt Schwitters"), which opened my eyes in regard to the poem *An Anna Blume*.

63 Cf. Christof Spengemann, "Der Künstler", in *Kurt Schwitters, Anna Blume. Dichtungen* (*Die Silbergäule*,
vol. 39/40), Hannover 1919, p. 4. The words are found in the Merz picture *Das Kreuz des Erlösers
(The Cross of the Saviour)*, 1919, lost (CR, no. 448) or in the drawing *Konstruktion. (Construction.)*,
1919 (CR, no. 557).

64 K. Schwitters "Selbstbestimmungsrecht der Künstler", in *Der Sturm* vol. X, 1919/20, issue 10, p. 140.

65 Schwitters 1920 (see note 1), p. 7.

66 K. Schwitters, "Banalitäten (4)", in *Merz 4*, 1923, p. 43, see KSAT 4, p. 97.

67 K. Schwitters, "Banalitäten (3)", in *Merz 4*, 1923, p. 40, see KSAT 4, p. 94.

68 K. Schwitters in *Merz 2*, 1923, p. 20, see KSAT 4, p. 43.

69 Ursula Kocher, "Mediale Grenzüberschreitungen", in KSAT 4, p. 794.

70 K. Schwitters in *Merz 2*, 1923, p. 20, KSAT 4, p. 43.

71 Ibid.

72 Edel Sheridan-Quantz, "Ich bin der Künstler … Kurt Schwitters and Molling's 'Awful' Illustrations",
in *The Kurt Schwitters Society UK Newsletter*, issue 10, May, ed. Gwendolen Webster, 2013, pp. 3 – 14.

73 Cf. KSAT 4, p. 394.

74 Cf. K. Schwitters, "Konsequente Dichtung", in *G. Zeitschrift für elementare Gestaltung* 3 (June 1924), p. 56.

75 Leonie Krutzinna, *Der norwegische Schwitters. Die Merz-Kunst im Exil*, Göttingen 2019.

76 K. Schwitters in the introduction to *Auguste Bolte (ein Lebertran). Tran Nr. 30*, Berlin 1923, p. 9.

77 Helmut Heißenbüttel, "Auguste Bolte und Anna Blume oder die Welt der Sprache", in *Kurt Schwitters
1887 – 1948. Ausstellung zum 99. Geburtstag*, ed. Sprengel Museum Hannover, Frankfurt am Main/Berlin
1986 and 1987, p. 43.

78 All citations from Kurt Schwitters, *Auguste Bolte (ein Lebertran). Tran Nr. 30*, Verlag Der Sturm,
Berlin 1923, p. 13.

79 Jens Tismar, *Das deutsche Kunstmärchen des zwanzigsten Jahrhunderts* (Germanistische Abhandlungen,
vol. 51), Stuttgart 1981, p. 57.

80 Cf. letter to Hans Richter, 18.2.1947, Sprengel Museum Hannover, inventory no. que 06839224.

81 Letter to Katherine S. Dreier, 16.9.1926, in Nündel 1974 (see note 19), p. 108.

82 Cf. the introduction to *Merz 24*, 1932, in KSAT 4, pp. 391–415 and Ursula Kocher, "Mediale
Grenzüberschreitungen", in KSAT 4, p. 796.

83 Letter to Max Gundermann, 16.11.1923 (folio 3), Stadtbibliothek Hannover, inventory no. SAH 208.

84 EYE, the filmmuseum Amsterdam, inventory no. FLM 63531.

85 KSAT 4, p. 413.

86 Cf. the hybrid edition of the series *Merz*, KSAT 4 and www.schwitters-digital.de.

87 Letter to Annie Müller-Widmann, 17.12.1939, in *Gerhard Schaub, Kurt Schwitters und die 'andere' Schweiz. Unveröffentlichte Briefe aus dem Exil*, Berlin 1998, p. 36.

88 Cf. letter to Helma Schwitters, 22.9.1942, in Nündel 1974 (see note 19), p. 172.

89 The allegedly original performance on the CD "Kurt Schwitters Ursonate", Wergo WER 6304-2, Mainz 1993, has been proven to be a recording by Ernst Schwitters.

90 Klaus Hinrichsen, "19 Hutchinson Square, Douglas, Isle of Man. Kurt Schwitters interniert in England 1940/41", in *Kurt Schwitters Almanach,* vol. 8, ed. Michael Erhoff and Klaus Stadtmüller, Kulturamt der Stadt Hannover, Hannover 1989, p. 108.

91 Kocher 2018 (see note 58), p 53.

92 Margarethe Dexel, *Kurt Schwitters*, undated typescript (ca. 1973), p. 20 and p. 18, copy in Kurt Schwitters Archiv, Sprengel Museum Hannover.

93 Werner Schumann, "Erinnerungen an Kurt Schwitters", in *Wegbereiter zur modernen Kunst. 50 Jahre Kestner-Gesellschaft*, ed. Wieland Schmied, Hannover 1966, p. 247.

94 Cf. K. Schwitters, "Merzdichtung", in *Merz 20*, 1927, p. 104, see KSAT 4, p. 350.

95 Schwitters 1924 (see note 74), p. 56.

96 Werner Graeff, "Schwitters auf dem Podium", unpublished typescript, no date, Nederlands Instituut voor Kunstgeschiedenis, Den Haag, inventory no. 1402.

97 Cf. Hinrichsen 1989 (see note 90), p. 108.

98 Annkathrin Sonder, "Kurt Schwitters' Merz- und Normalbühne zwischen 'explodierenden Dampfkesseln' und funktionaler Gestaltung", in "*Schlagkraft der Form*" 2018 (see note 58), p. 101.

99 Ibid.

100 Cf. K. Schwitters, "Aus der Welt 'MERZ'". Kurt Schwitters und Franz Rolan. Ein Dialog mit Einwürfen aus dem Publikum", in *Der Sturm*, vol. XIV, issue 4 (April), ed. Herwarth Walden, Berlin 1923, pp. 49 – 56.

101 Cf. Sonder 2018 (see note 98), p. 69.

102 K. Schwitters in *Merz 1*, 1923, p. 11, see KSAT 4, p. 19.

103 Cf. Brigitte Franzen, "Die Großstadt – ein gewaltiges Merzkunstwerk? Versuch über Kurt Schwitters und die Architektur", in *Neues Bauen der 20er Jahre. Gropius, Haesler, Schwitters und die Dammerstock-Siedlung in Karlsruhe*, exh. cat. ed. Badischen Landesmuseum Karlsruhe, Karlsruhe 1997, pp. 123 – 137.

104 *Merz 1*, 1923, p. 11, see KSAT 4, p. 19.

105 K. Schwitters, "Schloß und Kathedrale mit Hofbrunnen", in *Frühlicht. Eine Folge für die Verwirklichung des neuen Baugedankens*, ed. Bruno Taut, vol. I, no. 3, Magdeburg 1922, p. 87.

106 Ibid.

107 Christof Spengemann, "Merz – Die offizielle Kunst", in *Der Zweemann. Monatsblätter für Dichtung und Kunst*, vol. 1, issue 8 – 10 (June-August), Hannover 1920, p. 41.

108 Letter from Helma Schwitters to Hannah Höch and Til Brugman, 5.4.1933, in *Hannah Höch. Eine Lebenscollage*, vol. II.2: 1921–1945, ed. Künstlerarchiven der Berlinischen Galerie, Landesmuseum für Moderne Kunst, Photographie und Architektur, Ostfildern 1995, p. 482.

109 Letter to Alfred Barr Jr., Museum of Modern Art, New York, 23.11.1936, copy in the MoMA Archives, John Elderfield Files 1985 MoMA exh. #1400.

110 Cardinal/Webster 2011 (see note 9), p. 73.

111 Letter to Lotte Gleichmann-Giese, 6.10.1946, in Nündel 1974 (see note 19), p. 239.

112 Letter to Christof Spengemann, 11.11.1946, in Nündel 1974 (see note 19), p. 246.

113 Cf. letter to Christof and Luise Spengemann, 18.9.1946, in Nündel 1974 (see note 19), p. 229ff.

114 Cf. Werner Schmalenbach, *Kurt Schwitters*, Munich 1967 [1984]), p. 142, who reports the recollections of the son Ernst Schwitters.

115 Walter Gropius leaflet for "Ausstellung für unbekannte Architekten", organised by the Arbeitsrat der Kunst in Berlin, April 1919, quoted in Toni Stoss in *Der Hang zum Gesamtkunstwerk*, exhibition catalogue Kunsthaus Zürich 1983, p. 343 (emphasis in original).

116 Hanne Bergius, *Montage und Metamechanik*, Berlin 2000, p. 276.

117 Cf. Hanne Bergius, *Der Merzbau im Kontext des Architektonischen. Dekonstruktive Einflüsse von Dada Berlin, im speziellen von Johannes Baader*, lecture in SMH, http://www.sprengel-museum.de/bilderarchiv/ sprengel_deutsch/downloaddokumente/pdf/ks2007_bergius_der_merzbau.pdf, p. 2.

118 Cf. Dietmar Elger, *Der Merzbau von Kurt Schwitters. Eine Werkmonographie*, Cologne [1984] 1999, pp. 99–105.

119 Cf. Ulrich Krempel, "'Atelier Merzbau' – The Merzbau in the tradition of artists' studios and the problems of its reconstruction", in *In the Beginning Was Merz. From Kurt Schwitters to the Present Day*, exh. cat. ed. Susanne Meyer-Büser and Karin Orchard, Sprengel Museum Hannover, Ostfildern 2000, pp. 260–269.

120 This term is found in Schwitters' handwriting on the reverse of Theo van Doesburg's gouache *Lena im Interieur. Studie zu "Komposition XII"*, 1917, Stiftung Im Obersteg, deposited in the Kunstmuseum Basel.

121 Cf. list of works in *Merzgebiete. Kurt Schwitters und seine Freunde*, exh. cat., ed. Karin Orchard and Isabel Schulz, Sprengel Museum Hannover, Cologne 2006, p. 95ff.

122 Letter to Walter Dexel, 25.9.1924, in Nündel 1974 (see note 19), p. 92.

123 Letter to Annie Müller-Widmann, 28.1.1938, in Schaub 1998 (see note 87), p. 32.

124 K. Schwitters, "Das große E", manuscript, Sprengel Museum Hannover, inventory no. que 06840269, see *Kurt Schwitters. Das literarische Werk*, ed. Friedhelm Lach, 5 vols., Cologne/Munich 1973–1981 (2005), here vol. 5, p. 339.

125 Letter to Annie Müller-Widmann, 28.1.1938 (see note 87), p. 32.

126 Theo van Doesburg, *Study for a Composition* 1923; El Lissitzky, *Study for Proun 30 T*, 1920.

127 Letter to Katherine S. Dreier, 24.7.1937, in Nündel 1974 (see note 19), p. 138.

128 Cf. Cornelia Oßwald-Hoffmann, *Zauber... und Zeigeräume: Raumgestaltungen der 20er und 30er Jahre. Die "Merzbauten" des Kurt Schwitters und der "Prounenraum" sowie die Räumlichkeiten der Abstrakten des El Lissitzky*, Munich 2003, p. 189.

129 Cf. Gwendolen Webster, *Kurt Schwitters' Merzbau*, unpublished typescript, Dissertation, Open University, Milton Keynes, 2007, p. 217.

130 Letter to Ernst Schwitters, 22.6.1937, Sprengel Museum Hannover, inventory no. que 06838283.

131 Letter to Sophie Taeuber-Arp, 10.5.1938, in Nündel 1974 (see note 19), p. 145.

132 K. Schwitters, "Ich sitze hier mit Erika", 1936, typescript, Sprengel Museum Hannover, inventory no. que 06840374, see Lach 1973–1981 (see note 124), vol. 3, p. 124.

133 Cf. Karin Hellandsjø, *Kurt Schwitters "Merzhytta" in Norway*, Romsdalsmuseet, Molde 2019.

134 Cf. Krutzinna 2019 (see note 75), p. 89.

135 Cf. letter to Marguerite Hagenbach, 23.10.1947, in Nündel 1974 (see note 19), p. 286.

136 K. Schwitters 1919 (see note 40).

137 K. Schwitters, "Daten aus meinem Leben", 1926, manuscript, Sprengel Museum Hannover, inventory no. que 06840206, see Lach 1973–1981, vol. 5 (see note 124), p. 241.

138 Carola Giedion-Welcker, "Kurt Schwitters", in *Die Weltwoche*, 15.8.1947.

139 Cardinal/Webster 2011 (see note 9), p. 81

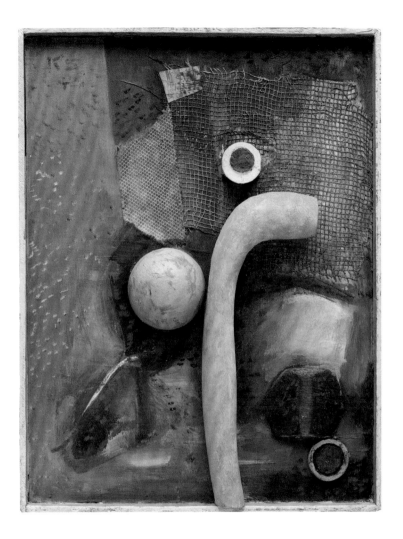

76

FREDLYST WITH YELLOW ARTIFICIAL BONE

1940–1941, 1945 and 1947, Merz picture

BIOGRAPHY
—

20 June 1887 Curt Hermann Eduard Carl Julius Schwitters is born in Hannover, the son of the businessman Eduard Schwitters and his wife Henriette.

1908–1915 Matriculation and university studies at the Kunstgewerbeschule Hannover and at the Königlich Sächsische Akademie der Künste in Dresden. Composes first poems; in August 1911 takes part in his first exhibition (Kunstverein Hannover).

1915/16 Marries Helma Fischer. Birth and death of son Gerd.

1917/18 Soldier for several months during the First World War; after being declared unfit for service, auxiliary service as workshop draughtsman at the Wülfel ironworks; in the winter semester 1917/18, studies architecture at the Technische Hochschule, Hannover. His work evolves towards abstraction.

1918 First exhibition in the gallery Der Sturm, Berlin; meets Kate Steinitz, Hans Arp, Raoul Hausmann and Hannah Höch; creates first collages and Merz pictures. Birth of son Ernst.

1919 Contact with the Dada artists in Zurich, Berlin and Cologne; invents the term "Merz" for his art; publication of the book of poetry *Anna Blume*. Creates Dadaist watercolours and stamp drawings; begins to collect material in notebooks.

1920 First exhibition of Merz pictures in Hannover (Kestner-Gesellschaft); in May, first public lectures in the gallery Der Sturm; in August takes part in exhibition at Galerie Arnold, Dresden; first participation in an exhibition of the American Société Anonyme, New York.

77
KURT SCHWITTERS, PRESUMABLY WHILE PERFORMING THE URSONATA
ca.1926 (Photo: Genja Jonas)

1921 Publication of the programmatic text *Merz*. Begins extensive travel and lecture activity; in September, "Anti-Dada-Merz Trip" to Prague.

1922 Creation of the first sound poems and the *i-Manifesto*. Beginning of involvement with De Stijl (Theo van Doesburg) and Russian Constructivism (El Lissitzky). Publication of two further volumes of poetry.

1923 Begins work on the *Merzbau* in Hannover; Dada tour with Theo and Nelly van Doesburg and Vilmos Huszár in the Netherlands (regular trips there until 1936); beginning of the publication of the *Merz* series; first (private) sound recording of parts of the *Ursonata* (VOX shellac record).

1924 Sets up Merz Advertising Bureau; participation with *Standard Merz Stage* in the "International Exhibition of New Theatre Technology" in Vienna, Paris, and New York.

1925 Reading of fairy tales at Bauhaus Weimar; summer holiday on island of Rügen.

1927 Solo exhibition tour "Great Merz Exhibition"; begins to transcribe the *Ursonata* into musical notation; founding of the group "die abstrakten hannover".

1928 Design of the festival revue and its programme with Kate Steinitz and Walter Gieseking for the "Fest der Technik" on 8 December 1928 in Hannover.

1929 Contract as typographer with the city administration of Hannover (until 1934); design of printed materials for the Dammerstocksiedlung project in Karlsruhe, directed by Walter Gropius; first trip to Scandinavia, followed by annual trips to Norway.

1930 Membership of PEN-Club; co-founder of the "Ring Hannoverscher Schriftsteller"; on 21 December last public performance in Germany at the "Künstler in Front" matinee in the Capitol-Hochhaus, Hannover.

Der Führer besichtigt die Ausstellung „Entartete Kunst"

78

ADOLF HITLER IN FRONT OF KURT SCHWITTERS' MERZBILD
IN THE EXHIBITION 'DEGENERATE ART'

Völkischer Beobachter, southern Germany edition from 18 July 1937

79

CERTIFICATE OF REGISTRATION FOR KURT SCHWITTERS

1941

1931 Member of the Abstraction-Création artists' association, Paris. Participation in an exhibition of the "ring neue werbegestalter" and in the "International Advertising Printing, Photos, and Photomontage" exhibition, Stedelijk Museum Amsterdam.

1932 Publication of *Merz 24 Ursonata*, last issue in the series as well as the last independent publication during lifetime. Radio recording of parts of *Ursonata* and poem *Ann Blossom has Wheels*.

1933 Attacked by the National Socialists in defamatory exhibitions of "degenerate" art; intensified retreat into "inner emigration" and focus on work on the *Merzbau* in Hannover, increased travel abroad.

1936 Participation in the exhibition "Cubism and Abstract Art" and "Fantastic Art, Dada, Surrealism" at the Museum of Modern Art, New York. His son leaves for Norway, where he follows in January 1937. Unsuccessful attempts to interest backers in the United States for his *Merzbau*.

1937 Confiscation of his works in German museums. Decides not to return to Germany. Begins work on the second Merz construction, the *House on the Slope* in Lysaker near Oslo.

1938 Cooperates with the Norwegian composer and organist Thorolf Høyer-Finn in Molde.

1939 In Norway, last meeting in summer with Helma Schwitters (who dies 1944 in Hannover).

1940 After German troops invade Norway, flees to Scotland; interned in various camps; sets up studio in Hutchinson Camp in Douglas on the Isle of Man.

1941 In December moves to London; acquaintance with Edith Thomas, later to become his partner; creates numerous sculptures.

1943 Destruction of parents' home with *Merzbau* in Hannover.

1944 Solo exhibition at the Modern Art Gallery in London.

1945 Moves to Ambleside in Lake District; earns his livelihood through portrait, landscape and still life painting. Increasing financial crisis and deterioration of health.

1946 Creates extensive series of Merz drawings (collages); begins to work on journal *PIN*, planned with Raoul Hausmann.

1947 Two Merz evenings organised at London Gallery; awarded grant from Museum of Modern Art, New York; begins work on new Merz construction, the *Merz Barn* on Cylinders Farm near Elterwater in the vicinity of Ambleside.

8 January 1948 Dies in hospital in Kendal; shortly before, receives British citizenship; interred in St. Mary's cemetery in Ambleside; in 1970, mortal remains transferred to Engesohder Friedhof in Hannover.

BIBLIOGRAPHY

—

PUBLICATIONS AND SOUND RECORDINGS BY KURT SCHWITTERS (SELECTION)

Anna Blume. Dichtungen (Die Silbergäule, vol. 39, 40), Hannover, Paul Steegemann Verlag 1919

Elementar. Die Blume Anna. Die neue Anna Blume. Eine Gedichtsammlung aus den Jahren 1918–1922, Berlin, Verlag Der Sturm 1922

Memoiren Anna Blumes in Bleie. Eine leichtfaßliche Methode zur Erlernung des Wahnsinns für Jedermann (Schnitter-Bücher. Die hohe Reihe), Freiburg im Breisgau, Walter Heinrich 1922; [facsimile edition Berlin 1964]; [reprint of all the contents of the Anna Blume volumes in: Kurt Schwitters, *Anna Blume und ich. Die gesammelten "Anna Blume"-Texte*, ed. Ernst Schwitters, Zurich, Verlag der Arche 1965]

Auguste Bolte (ein Lebertran). Tran Nr. 30, Berlin, Verlag Der Sturm 1923; [reprint Zurich 1966 and 2013] *Merz*, journal series, Hannover 1923–1932 [including sound recordings of *Ursonate* from 1923 and 1932, see below "Catalogues raisonnés and editions"]; [facsimile reprint of the issues: *Kurt Schwitters Merzhefte*, ed. Friedhelm Lach, Bern/Frankfurt am Main, H. Lang 1975]

Anna Blume. Scherzo der Ursonate, recited by Kurt Schwitters, Süddeutscher Rundfunk, Stuttgart, 5 May 1932, www.youtube.com/watch?v=6X7E2i0KMqM (last accessed: 13 December 2019); both recordings also included in: Kurt Schwitters. Urwerk. MP3-CD from Zweitausendeins, in collaboration with mOcean OTonVerlag, Munich 2007

CATALOGUE RAISONNE AND EDITIONS:

CR:
Kurt Schwitters. Catalogue raisonné, published by Sprengel Museum Hannover on behalf of the Niedersächsische Sparkassenstiftung, Norddeutsche Landesbank, Stadtsparkasse Hannover, Kurt and Ernst Schwitters Stiftung; ed. Karin Orchard and Isabel Schulz, 3 vols., Ostfildern-Ruit, Hatje Cantz 2000–2006

"Typographie kann unter Umständen Kunst sein", vol. 1: Kurt Schwitters. Typographie und Werbegestaltung, ed. Landesmuseum Wiesbaden, Wiesbaden 1990 [on pp. 118–257 the catalogue raisonné of typographical works, ed. Carola Schelle with Maria Haldenwanger]

Kurt Schwitters. Das literarische Werk, 5 vols., ed. Friedhelm Lach, Cologne, Dumont 1973–1981 [reprint Munich, dtv 2005]

KSAT3 and KSAT4:
Kurt Schwitters. Alle Texte, ed. Ursula Kocher and Isabel Schulz, Kurt und Ernst Schwitters Stiftung in cooperation with Sprengel Museum Hannover
vol. 3: Kurt Schwitters, *Die Sammelkladden 1919–1923*, ed. Julia Nantke and Antje Wulff, Berlin 2014
vol. 4: Kurt Schwitters, *Die Reihe Merz 1923–1932*, ed. Annkathrin Sonder and Antje Wulff, Berlin 2019
[free download of print version at www.degruyter.com; see also www.schwitters-digital.de]

EDITIONS OF TEXTS BY KURT SCHWITTERS TRANSLATED INTO ENGLISH:

The Merzbook: Kurt Schwitters Poems, ed. Colin Morton, Kingston, Ontario, Quarry Press 1987

Kurt Schwitters. Poems Performance Pieces Proses Plays Poetics, ed. Jerome Rothenberg and Pierre Joris, Philadelphia, PE / Cambridge, MA, Temple University Press 1993/2002

Lucky Hans And Other Merz Fairy Tales, ed. Jack Zipes, (series: Oddly Modern Fairy Tales), Princeton, NJ, Princeton University Press 2009/2014

Kurt Schwitters, *Three Stories*, ed. Jasia Reichardt, with a tribute by E. L. T. Mesens, London, Tate Publishing 2010

Kurt Schwitters. Myself and My Aims: Writings on Art and Criticism, ed. Megan Luke, translated by Timothy Grundy, Chicago, University of Chicago Press, will be published in 2020

MONOGRAPHS / EXHIBITION CATALOGUES (CHRONOLOGICAL)

Christof Spengemann, *Die Wahrheit über Anna Blume, Kritik der Kunst, Kritik der Kritik, Kritik der Zeit*, Hannover, Zweemann 1920 [reprint Hannover 1985]

Raoul Hausmann and Kurt Schwitters, *PIN and the Story of PIN*, London, Gaberbocchus 1962

Kate T. Steinitz, Kurt Schwitters. *A Portrait from Life, with Collision, a Science-Fiction Opera Libretto in BANALITIES*, by Kurt Schwitters and Kate Traumann Steinitz, and Other Writings, Berkeley/Los Angeles, Univ. of California Press 1968

Werner Schmalenbach, *Kurt Schwitters*, New York, Abrams 1967 / London, Thames & Hudson 1970

Kurt Schwitters. *Wir spielen, bis uns der Tod abholt. Briefe aus fünf Jahrzehnten*, ed. Ernst Nündel, Frankfurt am Main/Berlin/Vienna, Ullstein 1974 [reprint 1975]

Bernd Scheffer, *Anfänge experimenteller Literatur. Das literarische Werk von Kurt Schwitters* (Bonner Arbeiten zur deutschen Literatur, vol. 33), Bonn, Bouvier 1978

Ernst Nündel, *Kurt Schwitters in Selbstzeugnissen und Bilddokumenten*, Reinbek bei Hamburg, Rowohlt 1981
Dietmar Elger, *Der Merzbau von Kurt Schwitters. Eine Werkmonographie* (Kunstwissenschaftliche Bibliothek, vol. 12), Cologne, König 1984 [2nd edition Cologne, König 1999]

John Elderfield, *Kurt Schwitters*, New York/London, Thames and Hudson 1985

Kurt Schwitters. *"Bürger und Idiot". Beiträge zu Werk und Wirkung eines Gesamtkünstlers*, ed. Gerhard Schaub, Berlin, Fannei und Walz 1993

Gwendolen Webster, *Kurt Merz Schwitters. A Biographical Study*, Cardiff, University of Wales Press 1997

In the Beginning Was Merz. From Kurt Schwitters to the Present Day, exh. cat., ed. Susanne Meyer-Büser and Karin Orchard, Sprengel Museum Hannover, Ostfildern, Hatje Cantz 2000

Kurt Schwitters. Merz – a Total Vision of the World, exh. cat., ed. Museum Tinguely, Basel / Bern, Benteli 2004

Merzgebiete. Kurt Schwitters und seine Freunde, exh. cat., ed. Karin Orchard and Isabel Schulz, Sprengel Museum Hannover, Cologne, Dumont 2006

Evelyn Fux, *Schnitt durch die verkehrte "Merzwelt". Konzeptionen des Narrativen in der Prosa von Kurt Schwitters* (Aspekte der Avantgarde. Dokumente, Manifeste, Programme, vol. 10), Berlin, Weidler 2007
Sigrid Franz, *Kurt Schwitters' Merz-Ästhetik im Spannungsfeld der Künste* (Rombach Wissenschaften, series Cultura, vol. 45), Freiburg im Breisgau/Berlin/Vienna, Rombach 2009

Kurt Schwitters. Color and Collage, exh. cat., ed. Isabel Schulz, The Menil Collection Houston, New Haven/London, Yale University Press 2010

Roger Cardinal / Gwendolen Webster, *Kurt Schwitters*, Ostfildern-Ruit, Hatje Cantz 2011

Sch... The Journal of the Kurt Schwitters Society, issue 1, ed. Gwendolen Webster, Aachen, published annually since 2011

Anna Blume und ich. Zeichnungen von Kurt Schwitters, exh. cat., ed. Isabel Schulz on behalf of Kurt und Ernst Schwitters Stiftung, Hannover, in cooperation with Matthias Frehner and Claudine Metzger, Kunstmuseum Bern, Ostfildern, Hatje Cantz 2011

Lars Fiske, *Herr Merz* [Graphic Novel], Berlin, No Comprendo Press 2013

Schwitters in Britain, exh. cat., ed. Emma Chambers and Karin Orchard, Tate Britain and Sprengel Museum Hannover, Ostfildern, Hatje Cantz 2013

Megan R. Luke, *Kurt Schwitters Space, Image, Exile*, Chicago/London, University of Chicago Press 2014
Karin Hellandsjø, *Ultima Thule. Kurt Schwitters and Norway*, ed. Inger Schjoldager, Oslo, Orfeus 2016

Transgression und Intermedialität. Die Texte von Kurt Schwitters, ed. Walter Delabar, Ursula Kocher and Isabel Schulz (Moderne-Studien, vol. 20), Bielefeld, Aisthesis 2016

Julia Nantke, *Ordnungsmuster im Werk von Kurt Schwitters. Zwischen Transgression und Regelhaftigkeit* (spectrum Literaturwissenschaft, vol. 59), Berlin/Boston, de Gruyter 2017

Leonie Krutzinna, *Der norwegische Schwitters. Die Merz-Kunst im Exil*, Göttingen, Wallstein 2019

LIST OF ILLUSTRATIONS

—

125

17 Kurt Schwitters, *47.15 pine trees c 26*, 1946 and 1947, oil, photograph, paper and corrugated board on board, 25.3 × 21 cm (image), 45 × 37.6 cm (original support), Sprengel Museum Hannover, on loan from the Kurt and Ernst Schwitters Foundation

18 Kurt Schwitters, *Untitled (Silvery)*, 1939, aluminum paint and board on paper on tracing paper, 20 × 15.7 cm (image), 38 × 27.5 cm (support), Sprengel Museum Hannover, on loan from the Kurt and Ernst Schwitters Foundation

19 Kurt Schwitters, *Merz 1003. Pfauenrad* [Merz 1003. Peacock's Tail], 1924, oil and wood on cardboard, 72.7 × 70.6 cm, Yale University Art Gallery, New Haven (Connecticut) Gift of Société Anonyme Collection

20 Kurt Schwitters, *Motiv: Verschiebungen* [Motif: Displacements], 1930, oil on canvas, 80.4 × 66.2 cm, Sprengel Museum Hannover, on loan from the Kurt and Ernst Schwitters Foundation

21 Kurt Schwitters, *Neues Merzbild* [New Merz Picture], ca. 1931, oil, wood, board and wheel on wood, 83 × 110.5 cm, Museum Insel Hombroich

22 Kurt Schwitters, *MERZ 1926,12. "Little Seamen's Home."*, 1926, oil, wood, fragment of wheel and metal on cardboard, 66.1 × 52 cm, Kunstsammlung Nordrhein-Westfalen, Düsseldorf

23 Kurt Schwitters, *Merzbild P. rosa* [Merz Picture P. Pink], 1930, oil, cardboard, textile and wood on wood, 50 × 39.4 cm, Sprengel Museum Hannover, NORD/LB Collection in the Niedersächsische Sparkassenstiftung

24 Kurt Schwitters, *Fossil*, 1944/1946, oil, agaric, shoe sole and cardboard on wood, 18.8 × 18.2 × 4.6 cm, Sprengel Museum Hannover, on loan from the Kurt and Ernst Schwitters Foundation

25 Kurt Schwitters, *AERATED V*, 1941, oil, wood and table tennis ball on plywood, 32 × 27.9 cm, Sprengel Museum Hannover, on loan from the Kurt and Ernst Schwitters Foundation

26 Kurt Schwitters, *Das Merzbild* [The Merzpicture], 1919 (lost), picture postcard Paul Steegemann Verlag, Hannover, Sprengel Museum Hannover, gift of Ernst Schwitters, Lysaker

27 Kurt Schwitters (typography), *MERZ = von Kurt Schwitters* [MERZ = by Kurt Schwitters], 1923, letterpress on paper, 44.5 × 57 cm, Berlinische Galerie – Landesmuseum für Moderne Kunst, Fotografie und Architektur

28 Kurt Schwitters and Albert Schulze (execution), *Untitled (Inlaid Box SK/P for Sophie and Paul Erich Küppers)*, 1920, wood, ivory and mother of pearl, 23 × 23 × 6.7 cm, Museum August Kestner, Hannover, on loan from the Fritz Behrens Stiftung, Hannover

29 Kurt Schwitters, *Bleichsucht und Blutarmut – Interessante Briefe* [Chlorosis and Anaemia – Interesting Letters], 1920, notebook with collaged binding, 20.8 × 15.8 cm, Sprengel Museum Hannover, on loan from the Kurt and Ernst Schwitters Foundation

30 Kurt Schwitters, *Mz. 151 Wenzel Kind Madonna mit Pferd* [Mz. 151 Wenzel Child Madonna with Horse], 1921, paper on paper, 17.2 × 12.9 cm (original passepartout cutout), 19.3 × 14.9 cm (image), 29.8 × 21.4 cm (original passepartout), Sprengel Museum Hannover, NORD/LB Collection in the Niedersächsische Sparkassenstiftung

31 Kurt Schwitters, *Madonna*, 1941/42, plaster, wood and corrugated board, painted, 57.8 × 13.3 × 15.6 cm, Sprengel Museum Hannover, NORD/LB Collection in the Niedersächsische Sparkassenstiftung

32 Kurt Schwitters, *Merz 20 Kurt Schwitters Katalog* [Merz 20 Kurt Schwitters Catalogue], Hannover, Merz Verlag, 1927, letterpress on art paper, wire stitching, 24.5 × 16 cm, 4 leaves, 8 pp., Sprengel Museum Hannover, Schenkung Ernst Schwitters, Lysaker

33 Kurt Schwitters, *Untitled (Landscape with Snowfield: Opplusegga)*, 1936, oil on wood, 72.2/71.7 × 60.5 cm, Sprengel Museum Hannover, on loan from the Kurt and Ernst Schwitters Foundation

34 Ernst Schwitters (photographer), *Kurt Schwitters at the easel in Norway*, 1935, silver bromide gelatin, 17 × 11 cm, Sprengel Museum Hannover, on loan from the Kurt and Ernst Schwitters Foundation

35 Kurt Schwitters, *Oldenfoss*, 1931, oil on cardboard, 37 × 46 cm, private collection

36 Kurt Schwitters, *Untitled (Is Fjord near Åndalsnes)*, ca. 1938, coloured pencil on board, 15.7 × 19.8 cm, Sprengel Museum Hannover, on loan from the Kurt and Ernst Schwitters Foundation

37 Kurt Schwitters, *Kirkston Pass*, 1948, pencil on paper, 11.2 × 17.3 cm, Sprengel Museum Hannover, on loan from the Kurt and Ernst Schwitters Foundation

38 Kurt Schwitters, *Merzbild mit Kette* [Merz Picture with Chain], 1937, oil, metal chain, plaster and iron on plywood, 72.7 × 49 cm, Sprengel Museum Hannover, 2004 donated by Roswitha von Bergmann, née von der Leyen

39 Kurt Schwitters, *Untitled (Merz Picture with Rainbow)*, 1939, oil, cardboard, wood, metal and hub with spokes on wood, 155.9 × 121 cm, Yale University Art Gallery, New Haven (Connecticut), Charles B. Benenson Collection

40 Kurt Schwitters, *Prikken paa I en* [Dot on the I], 1939, coloured pencil, paper, corrugated board and board on wood, 75.5 × 91.8 cm, Musée national d'art moderne, Centre Georges Pompidou, Paris

41 Kurt Schwitters, *Green over yellow.*, 1947, tracing paper and paper on paper, 16.5 × 13.5 cm (image), 30.4 × 22.7 cm (original support), Sprengel Museum Hannover, on loan from the Kurt and Ernst Schwitters Foundation

42 Kurt Schwitters, *Untitled (The Hitler Gang)*, 1944, oil, canvas, board and paper on paper, 34.8 × 24.6 cm (image), 50.5 × 40.4 cm (original passepartout), Sprengel Museum Hannover, on loan from the Kurt and Ernst Schwitters Foundation

43 Kurt Schwitters, *Bild mit Raumgewächsen / Bild mit 2 kleinen Hunden.* [Picture with Spatial Growths / Picture with 2 Little Dogs.], 1920 and 1939, oil, paper, board, cardboard, textile, lace, wood, hairs, ceramic and metal on cardboard, 97 × 69 cm, Tate Modern, London

44 Kurt Schwitters (typography), *Business Card Kurt Schwitters*, 1923–1929, letterpress on board, 5.8 × 9.4 cm, Sprengel Museum Hannover, on loan from the Kurt and Ernst Schwitters Foundation

45 Kurt Schwitters, *Merz 4 Banalitäten [Banalities, No. 4 from the series Merz]*, Hannover, Merz Verlag, 1923, letterpress, wire stitching, 23.2 × 14.8 cm, 8 leaves, 16 pp., Sprengel Museum Hannover, loan from the Kurt and Ernst Schwitters Foundation

46 Kurt Schwitters, *Werbe Merz [Merz Advertising]*, notebook, 1924–1927, re-used issues of Merz 6 (board and paper, staple binding), cover reinforced with cardboard, collaged and labelled; inner pages glued over with paper and printed fragments, 22 × 14.5 cm, 8 leaves, 16 pp., Sprengel Museum Hannover

47 Kurt Schwitters, *page from: notebook Werbe Merz* [Merz Advertising], 1924–1927 (see fig. 46), folios 6v and 7r with envelope Aposs Verlag Hannover Georgstrasse 34 and Buchheisters Woll-kenkratzer Hannover

48 Kurt Schwitters (typography), *Zeugnisheft für die Stadttöchterschule III* [School report notebook for municipal girls' school III], 1930, letterpress on board and paper, 20.8 × 14.5 cm, 10 leaves, 39 pp., Sprengel Museum Hannover, on loan from the Kurt and Ernst Schwitters Foundation

49 Kurt Schwitters (typography), *Weshalb sind Sie nicht im Opernhause und im Schauspielhause abonniert?* [Why have you no subscriptions for the opera house and the theatre?] Hannover Municipal Stages, Season 1930/31, 1930, letterpress on paper, 22.5 × 14.2 cm, 8 pp., 4 leaves, Sprengel Museum Hannover, loan from NORD/LB Kulturstiftung

50 Kurt Schwitters (typography), *advertisement for werbe-gestaltung merz-werbe hannover* [advertising design merz advertising hannover], 1929, 10.5 × 15.5 cm (from Exhibition Karlsruhe Dammerstock-Siedlung. The Functional Flat. 23 Types, 228 Flats, ed. by Landeshauptstadt Karlsruhe, Karlsruhe 1929, p. 15)

51 Kurt Schwitters, *Aq. 21. Anna Blume und ich.* [Aq. 21. Ann Blossom and I.], 1919, coloured pencil, aquarelle and ink on paper, 21.1 × 17.2 cm (original passepartout cutout), 37.3 × 27 cm (original passepartout), Sprengel Museum Hannover, on loan from the Kurt and Ernst Schwitters Foundation

52 Kurt Schwitters, *Anna Blume. Dichtungen* [Ann Blossom. Poems], Paul Steegemann Verlag, Hannover, 1919, 22 × 14.5 cm, 37 pp., printed by Edler & Krische, Sprengel Museum Hannover, on loan from the Kurt and Ernst Schwitters Foundation

53 Kurt Schwitters, *An Anna Blume* [Ann Blossom has Wheels], poster Paul Steegemann Verlag, Hannover, 1920, offset printing (press proof), 97 × 69.5 cm, Sprengel Museum Hannover, on loan from private collection

54 Kurt Schwitters, *Z i 25 Engel der Strasse.* [Z i 25 Angel of the Road.], 1926, paper (misprint, trimmed), 16.7 × 13.4 cm (original passepartout cutout), 19.6 × 15.2 cm (image), 32.3 × 24.7 cm (original passepartout), Sprengel Museum Hannover, on loan from the Kurt and Ernst Schwitters Foundation

55 Kurt Schwitters, *Das i-Gedicht* [The i poem], 1922, (from Kurt Schwitters, *Elementar. Die Blume Anna Die neue Anna Blume. Eine Gedichtsammlung aus den Jahren 1918–1922* [Elementary. The Blossom Ann. The New Ann Blossom. A Collection of Poems from the Years 1918–1922], Verlag Der Sturm, Berlin 1923, p. 30), Sprengel Museum Hannover, on loan from the Kurt and Ernst Schwitters Foundation

56 Kurt Schwitters, *Sound poem (bii büll ree ...)*, 9 October 1936, pencil on paper, 34.5 × 25 cm, 1 leaf, 1 p., Sprengel Museum Hannover, on loan from the Kurt and Ernst Schwitters Foundation

57 Kurt Schwitters, *Gesetztes Bildgedicht* [Set Visual Poem], 1922 (from: Kurt Schwitters, *Elementar. Die Blume Anna. Die neue Anna Blume. Eine Gedichtsammlung aus den Jahren 1918–1922* [Elementary. The Blossom Ann. The New Ann Blossom. A Collection of Poems from the Years 1918–1922], Verlag Der Sturm, Berlin 1923, p. 31), Sprengel Museum Hannover, on loan from the Kurt and Ernst Schwitters Foundation

58 Kurt Schwitters, *ESIR*, 1947, paint, burlap and paper on paper, 24.1 × 16.3 cm (original passepartout cutout), 40.7 × 31 cm (original passepartout), Sprengel Museum Hannover, on loan from the Kurt and Ernst Schwitters Foundation

59 Kurt Schwitters, *Merz 24 Ursonate (Dritter Teil: Scherzo)* [Ursonata, No. 24 from the series Merz (third section: scherzo)], Hannover, Merz Verlag, 1932, typography: Jan Tschichold, letterpress, wire stitching, 20.5 × 14.5 cm, 20 leaves, 40 pp., Sprengel Museum Hannover, on loan from the Kurt and Ernst Schwitters Foundation

60 Kurt Schwitters, *Ursonate* [Ursonata], 1938–1939, pencil and ink on manuscript paper, 34.5 × 25.8 cm, 1 sheet, 3 pp., Sprengel Museum Hannover, on loan from the Kurt and Ernst Schwitters Foundation

61 Ernst Schwitters (photographer), *Kurt Schwitters performing his Ursonata*, London, 1944, vintage print, silver bromide gelatin, 12 × 12 cm, Sprengel Museum Hannover, on loan from the Kurt and Ernst Schwitters Foundation

62 Kurt Schwitters (typography), *Einladung zum Merzabend. Kurt Schwitters liest seine Auguste Bolte* [Invitation to Merz evening], 1923/24, letterpress on board, 15.5 × 10.5 cm, Stadtbibliothek Hannover

63 Kurt Schwitters, *Normalbühne Merz [Standard Stage Merz] (Original Model in Different Arrangements)*, 1924, original model probably made of wood, painted; silver bromide gelatin, each 6.5 × 9.4 cm, Sprengel Museum Hannover, gift of Ernst Schwitters, Lysaker

64 Kurt Schwitters, *Schloß und Kathedrale mit Hofbrunnen* [Castle and Cathedral with Courtyard Well], 1920/1922, wood and cork, lost

65 Kurt Schwitters, *Haus Merz* [Merz House], 1920, wood, metal (clockwork) and fabric-covered button, lost

66 Kurt Schwitters, *Untitled (Merz Column)*, 1923/1925, paper, board, metal, plaster, wood, crochet cloth, cow's horn, laurel branch, sconce and diverse materials, destroyed in 1943 (unknown photographer, glass plate negative 12 × 9 cm, Sprengel Museum Hannover)

67 Kurt Schwitters, *Der Merzbau in Hannover (Große Gruppe)* [The Merz Construction in Hannover (Large Group)], 1933, installation, paper, board, cardboard, plaster, glass, mirrored glass, metal, wood, plaster, stone, painted, diverse materials, electric lighting, destroyed in 1943 (photograph: Wilhelm Redemann, glass plate negative 24 × 18 cm, Sprengel Museum Hannover)

68 Kurt Schwitters, *Ground plan of Merz Construction in Hannover (in a letter to Christof and Luise Spengemann, 25 April 1946)*, pencil on paper, ca. 393 × 580 × 460 cm, 15 leaves, 15 pp., Stadtbibliothek Hannover

69 Kurt Schwitters, *Hall in the hut on Hjertøya*, 1932–1939, stone hut with applied paint, paper, plaster, stone, wood and diverse materials, ca. 167/150 × 100 × 170/142 cm, state ca. 2010, before the interior of the hut was transferred to the Romsdalsmuseet, Molde

70 Kurt Schwitters, *The hut on Hjertøya*, 1932–39, state in 2016

71 Kurt Schwitters, *Reisetruhe [Trunk]*, 1926–1934, wood, collaged inner partition, 77 × 73 × 65 cm (closed), 114 × 73 × 110 cm (opened), Sprengel Museum Hannover, on loan from the Kurt and Ernst Schwitters Foundation

72 Kurt Schwitters, *Dancer*, 1943, wood and plaster, painted, 77.5 × 22 × 13 cm (sculpture), 19.5 × 14.3 × 5.2 cm (base), Galerie Gmurzynska, Zurich

73 Kurt Schwitters, *Untitled (Shell Sculpture)*, 1947, wood, plaster, seashell and cardboard, painted, 9.7 × 11.5 × 8.4 cm (sculpture), 11.2 × 8 cm (pedestal), Sprengel Museum Hannover, on loan from the Kurt and Ernst Schwitters Foundation

74 Kurt Schwitters, *Relief wall in the Merz Barn*, 1947, unfinished, oil, plaster, wood, branch, root, blossoms, bamboo sticks, stone, ceramic, metal (window frame), wire, lattice, rope, fragment of wheel, fragment of mirror frame (gilded), porcelain, rubber ball, rose from a child's watering can and diverse materials on natural stone wall, ca. 300 × 457 cm (wall before removal); 178 cm (height left), 266 cm (height right) × 470 × 70 cm (current dimensions after transfer), Hatton Gallery, Newcastle (photograph: Ernst Schwitters, 1953/1960)

75 Kurt Schwitters, *Untitled (Picture with Tin and Band)*, ca. 1945, oil, metal (tin lid), iron, wood and plastic lump on wood, 51.8 × 37.8 cm, Sprengel Museum Hannover, on loan from the Kurt and Ernst Schwitters Foundation

76 Kurt Schwitters, *Fredlyst with Yellow Artificial Bone*, 1940–1941, 1945, and 1947, oil, net, paper, board, plaster and wood on wood, 48.6 × 37.6 cm (image), 50.4 × 39.5 cm (original frame), Sprengel Museum Hannover, on loan from the Kurt and Ernst Schwitters Foundation

77 Genja Jonas (photographer), *Kurt Schwitters, Presumably while Performing the Ursonata*, ca. 1926, silver bromide gelatin, 13 × 9.5 cm, Sprengel Museum Hannover, Kurt Schwitters Archiv, Hannover, on loan from the Kurt and Ernst Schwitters Foundation

78 *Adolf Hitler in Front of Kurt Schwitters' Merzbild in the Exhibition "Degenerate Art"* (from Völkischer Beobachter, southern Germany edition from 18 July 1937)

79 *Certificate of Registration for Kurt Schwitters*, 1941, letterpress, wire stitching, Sprengel Museum Hannover, on loan from the Kurt and Ernst Schwitters Foundation

80 Genja Jonas (photographer), *Portrait of Kurt Schwitters*, 1926, silver bromide gelatin, 16.5 × 12 cm, Sprengel Museum Hannover, on loan from the Kurt and Ernst Schwitters Foundation

80
PORTRAIT OF KURT SCHWITTERS
1926 (Photo: Genja Jonas)

PHOTO CREDITS

IMPRINT

This publication has been made possible by the support of the Kurt and Ernst Schwitters Foundation and the Sprengel Museum Hannover.

Published by
Hirmer Verlag GmbH
Bayerstraße 57–59
80335 Munich, Germany

Cover illustration: Kurt Schwitters, *Untitled (ELITE)*, detail, 1923/24 (see fig. 10).
On back of the cover the picture is reproduced as a mirror image.

www.hirmerpublishers.com

Translation: David Sánchez, Cano (Madrid)
Copy-editing / Proofreading: Jane Michael, Munich
Project Management: Tanja Bokelmann, Munich
Design / Typesetting: Marion Blomeyer, Munich
Pre-Press / Repro: Reproline mediateam GmbH, Munich
Printing / Binding: Passavia Druckservice GmbH & Co. KG, Passau

Bibliographic information published by the Deutsche Nationalbibliothek The Deutsche Nationalbibliothek lists this publication in the Deutsche Nationalbibliografie; detailed bibliographic data are available on the Internet at http://dnb.dnb.de.

ISBN 978-3-7774-3446-9
Printed in Germany